Geet Govinda

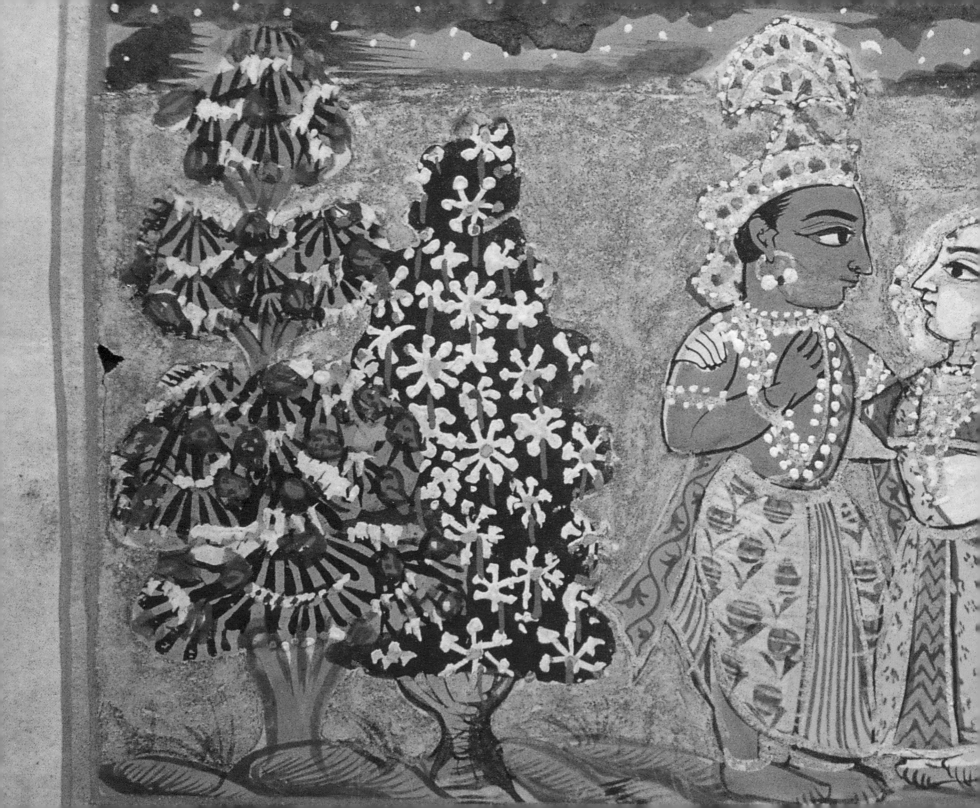

Geet Govinda

Paintings in Kanheri Style

Narmada Prasad Upadhyaya

Shri Beni Madhava Prakashan Graha
in association with
Mapin Publishing

First published in India in 2006 by
Shri Beni Madhava Prakashan Graha
Indira Gandhi Ward, Harda 461331
Madhya Pradesh

in association with
Mapin Publishing Pvt. Ltd.

Simultaneously published in the
United States of America in 2006 by
Grantha Corporation
77 Daniele Drive, Hidden Meadows
Ocean Township, NJ 07712
E: mapinpub@aol.com

Distributed in North America by
Antique Collectors' Club
East Works, 116 Pleasant Street, Suite 60B
Easthampton, MA 01027
T: 1 800 252 5231 • F: 413 529 0862
E: info@antiquecc.com
www.antiquecollectorsclub.com

Distributed in the United Kingdom, Europe and
the Middle East by
Art Books International Ltd
Unit 200 (a), The Blackfriars Foundry
156 Blackfriars Road
London, SE1 8EN UK
T: 44 207 953 7271 • F: 207 953 8547
E: sales@art-bks.com • www.art-bks.com

Distributed in Southeast Asia by
Paragon Asia Co. Ltd.
687 Taksin Road, Bukkalo, Thonburi
Bangkok 10600 Thailand
T: 66 2877 7755 • F: 2468 9636
E: rapeepan@paragonasia.com

Distributed in the rest of the world by
Mapin Publishing Pvt. Ltd.
Usmanpura, Ahmedabad 380014 India
T: 91 79 2754 5390 / 2754 5391 • F: 2754 5392
E: mapin@mapinpub.com • www.mapinpub.com

Text © Narmada Prasad Upadhyaya
Photographs © Samarth Wagdevta Mandir,
by Jai Nagda

ISBN: 81-88204-18-8 (Mapin)
ISBN: 1-890206-56-3 (Grantha)
LC: 2002115393

Designed by Janki Sutaria / Mapin Design Studio
Edited by Diana Romany / Mapin Editorial
Processed by Reproscan, Mumbai
Printed in India by PragatiOffset

Captions

Front jacket:
The wind burns the heart, see page 41
Back jacket:
Manini Radha, see page 72
Pages 2-3:
Krishna and a *gopi*, see page 42
Page 5:
Radha and Krishna in the grove, see page 35

Dedicated to the memory of

Late Shankar Shri Krishna Dev,

who searched and preserved

this unique and eternal

cultural heritage of our

glorious tradition forever.

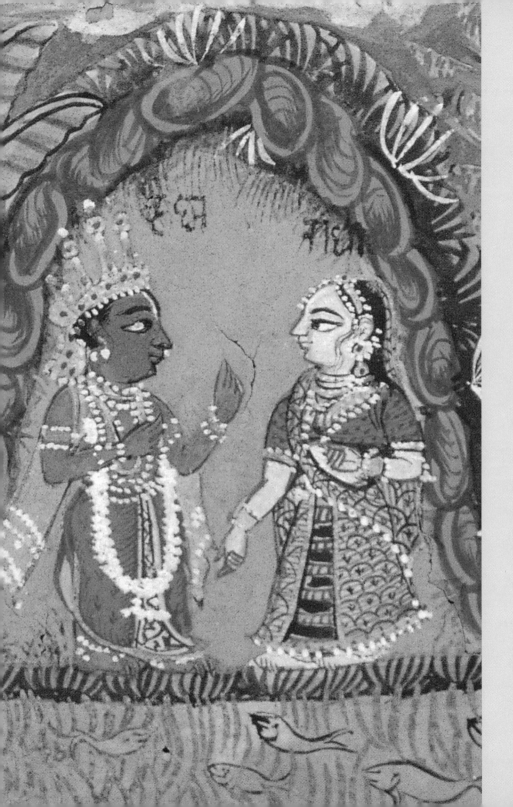

Contents

Acknowledgements

The Late Dr. Vidhya Niwas Misra blessed and inspired me to write about these miniatures. In 1997, when I participated in an international seminar, held in the memory of late Shri Rai Krishna Das at Banaras under the auspices of Banaras Hindu University, I was able to discuss these miniatures and seek valuable suggestions, guidance and inspiration from Dr. Robert Skelton, Rai Anand Krishna, Dr. Kapila Vatsyayan, Dr. Asok Kumar Das, Shri Jagdish Mittal, Dr. Shridhar Andhare, Dr. R.D. Choudhary, Dr. K. Bautze, Dr. R.P. Sharma, Dr. T.K. Biswas and Dr. Bhanu Agrawal. During my recent visit to Australia, I received valuable suggestions from Dr. Jim Masselos, who examined the material thoroughly. Dr. Robyn Maxwell of the National Gallery of Australia and Dr. Richard Barz shared their opinions, which enriched my thinking. Ms. Bronwyn Campbell, Assistant Curator, NGA, took great interest in arranging a seminar, centred on the *Geet Govinda* in Canberra discussing these miniatures in the context of other miniatures based on the same theme preserved in different museums.

Dr. M.B. Shaha, Dr. Chitle of Samarth Wagdevta Mandir and Mr. Milind Shewde also took keen interest in showing me this illustrated manuscript and making available the relevant information. I am grateful to them and the officials of Samarth Wagdevta Mandir, who generously permitted me to use these miniatures for publication.

My friend, Jai Nagda painstakingly took photographs and made transparencies of these miniatures. I am greatly indebted to him. Dr. B.G. Sharma, an eminent historian and devoted scholar, patiently examined and corrected the text. His blessings are infinite. A Sanskrit scholar of high repute, Dr. S.L. Swarnakar, put in hard labour in translating the couplets of this manuscript and pointing out some salient features of it.

Dr. Ram Murti Tripathi, Shri Om Prakash Mehra, Dr. Mohan Gupta and Dr. Shyam Sundar Nigam are highly respected scholars, who helped me and corrected my mistakes.

All my family members are responsible for inspiring me. They provided the time and liberty needed to undertake this work. I especially bless Vijya Upadhyaya, my sister-in-law for the identification of the Marathi ornaments, clothes and colours etc., found in these miniatures. During my stay in Australia, my brother-in-law Jai, sister Nandan and niece Tuhina were a great help for the preparations of the seminar.

All my official colleagues always encouraged and supported me. I want to thank Mr. D. Arjhariya, who wandered in the dense forests and other destinations of Khandesh with me in order to collect important information.

I am grateful to Mr. Kamlesh Wadhwani, who carefully typed the text with intense devotion and care.

Finally, I owe my deepest gratitude to Mapin—an institution devoted to art and art lovers—who generously considered this monograph and pictures for publication. Without their initiation this superb and eternal heritage of India would not have come to light in this charming form. ■

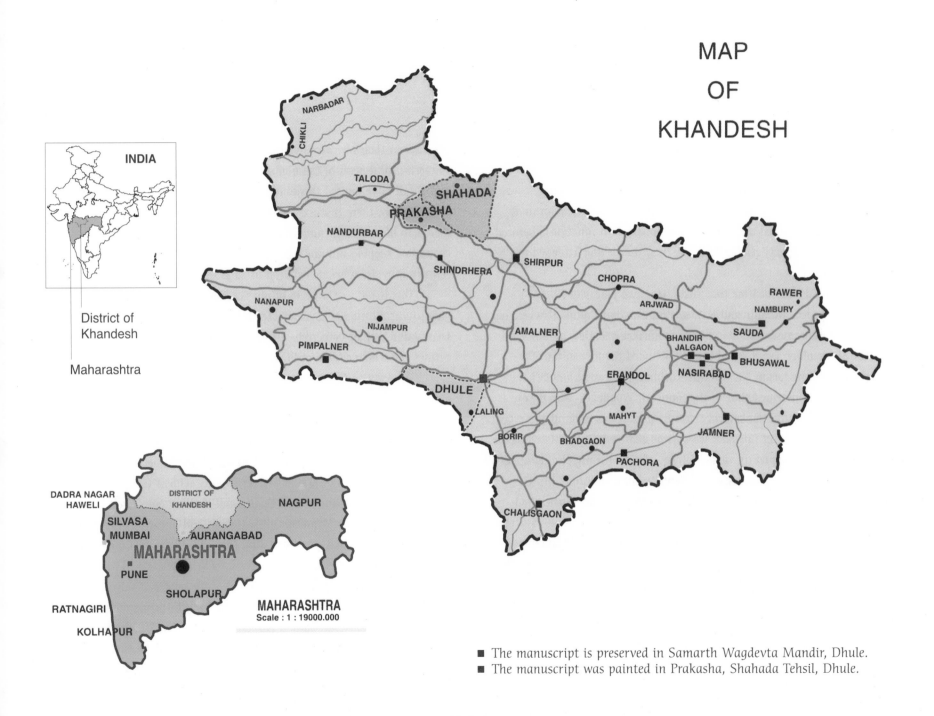

MAP

OF

KHANDESH

INDIA

District of
Khandesh

Maharashtra

NARBADAR

CHIKLI

TALODA

SHAHADA

PRAKASHA

NANDURBAR

SHINDRHERA

SHIRPUR

CHOPRA

RAWER

NANAPUR

ARJWAD

NAMBURY

NIJAMPUR

AMALNER

SAUDA

PIMPALNER

BHANDIR
JALGAON

BHUSAWAL

ERANDOL

NASIRABAD

DHULE

LALING

MAHYT

JAMNER

BORIR

BHADGAON

PACHORA

CHALISGAON

DADRA NAGAR
HAWELI

DISTRICT OF
KHANDESH

NAGPUR

SILVASA

MUMBAI

AURANGABAD

MAHARASHTRA

PUNE

RATNAGIRI

SHOLAPUR

MAHARASHTRA
Scale : 1 : 19000.000

KOLHAPUR

■ The manuscript is preserved in Samarth Wagdevta Mandir, Dhule.
■ The manuscript was painted in Prakasha, Shahada Tehsil, Dhule.

Preface

It was a cool evening when my wife Anjana urged me to go to a sacred town hallowed by the memories of Sai Baba—one of India's revered sages—near Shirdi in Maharashtra, a famous place of pilgrimage. It was the first month of 1995 and Dr. M.B. Shaha, an eminent scholar and social worker had invited me to release two books at a function organized by Hindi lovers. I finally chalked out the programme and attended the function in Dhule.

Dr. Shaha informed me that there were two places in Dhule—Samarth Wagdevta Mandir and Rajwade Sanshodhan Mandal—where old manuscripts were preserved. Shri Shankar Shrikrishna Dev, an eminent collector of art objects and social worker, founded the former and the famous Marathi historian Vishvanath Kashinath Rajwade founded the latter. I was also informed that in the Samarth Wagdevta Mandir, an illustrated *pothi* containing several coloured miniatures remains preserved, and that the words 'Geet Govinda' were embossed on it.

After that I frequently visited Dhule, along with my photographer friend, Jai Nagda. I also requested my departmental colleague Mr. D. Arjhariya to collect as much information as possible. The journey had thus commenced.

Geet Govinda is a marvellous poem, which has stirred the minds of readers, artists, dancers and musicians to such frenzy that they themselves become the *geet* or song while reading, dancing, painting, acting or playing on their instruments. This fantastic poem written by Jaideva is truly the culmination of the history of Indian fine arts.

In the context of Indian miniatures, *Geet Govinda* has been painted in almost every representative style. The connoisseurs and critics of Indian art have in their own ways viewed these paintings. They have interpreted the technical aspects of these miniatures, while the scholars of Sanskrit and Hindi have limited themselves to the interpretation of the poem. Consequently, there is still a gap between the reading of the poem and the execution of paintings that remains unexplored. These miniatures need to be studied keeping in mind the fact that this great lyric of the 12th century provides a bridge between art and literature.

This is not just a poem of physical love but a work of great philosophical content. Love depicted in the *Geet Govinda* is not a matter of secrecy and cannot be perceived as exclusively physical. The *Geet Govinda* defines the true meaning of love.

The *leela* or divine play of Krishna takes place in darkness and ends at dawn. Jaideva frequently deviates from the thematic norms and makes unique this immortal work. Over the years, the *ashtapadis* or couplets of *Geet Govinda* have found favour in different disciplines of art like dance, music and painting. Consequently, it attained great popularity and this harmonious blending of Radha and Krishna is evident throughout the *Geet Govinda*. The divine love of Radha and Krishna crossed all barriers of language, caste and tradition. It was sung and danced by expert artists and tribal Abhirs alike. The Rasa dance in a temple turned into Hallisak in the fields of Khandesh.

Kama, passion, was considered one of the modes of salvation. It was considered the congress of *Prakrati* and *Purush*—primordial matter and the primal spirit, *Atma* and *Parmatma*—the self and the universal soul. The Indian ideal of love signifies mystic and emotional surrender before the beloved. In Indian philosophy, the union of sexes is equivalent to the

syllable, *Aum* (ॐ) wherein the two sexes come together, each fulfilling the desire of the other.

Dr. Vidhya Niwas Misra, an eminent scholar of Sanskrit, in his book *Radha Madhav Rang Rangi* (A Commentary on Geet Govinda) observes, "No poem based on physical love could succeed in carrying the burden of the density of sentiments and no poem could have succeeded in giving so powerful a direction to the stream of sentiments that the ocean would have become eager to merge himself into a drop."

It is my opinion that *Geet Govinda* represents the basic Indian attitude towards love. Radha and Krishna, though two different souls, exist as one. Radha yearns for a complete merging with Krishna. *Geet Govinda* is a poem symbolizing supreme oneness.

In the subsequent chapters, I have tried to provide a brief biography of Jaideva. The chapter 'Jaideva and Geet Govinda' deals with his life, the miraculous legends and stories that surround him and the significance of the *Geet Govinda*. As Radha is the central figure of this poem, there follows a discussion of this legendary character. This is followed by 'Kanheri Geet Govinda'. I chanced upon the Kanheri *Geet Govinda* based upon a charmingly illustrated manuscript, which I found in Khandesh. The term 'Kanheri' connotes a style and is probably derived from 'Khandesh', the land of Krishna, where Krishnayat tradition held its sway.

The album shows us fantastic colourful depictions, painted by unknown artists in the Kanheri style. I hope that all art lovers will admire these miniatures, which contain a blend of the folk and traditional features, and appreciate the devotion of the indigenous artists for Radha and Madhava. ∎

Jaideva and Geet Govinda

Jaideva composed the verses of *Geet Govinda* and conjured up an enduring image of Radha and Krishna for all times to come. There is a controversy among the scholars of Bengal, Orissa and Mithila regarding the whereabouts of his birth place. It is probable that he was born in the village Kindubilva or Kenduli in the Birbhum district of West Bengal in circa CE 1108. Other scholars have regarded Jaideva as a resident of Gujarat. Although the *Geet Govinda* was very popular in Gujarat, it cannot be established that it was the birthplace of Jaideva. Dr. Suniti Kumar Chaterjee, an eminent scholar of Sanskrit, finally resolved the controversy in his famous monograph *Jaideva: Makers of Indian Literature*, and established that Jaideva was born in Kindubilva.

There is no adequate biographical information available regarding his early life. Barbara Stoler Miller, a prominent scholar, hailed Jaideva as a wandering poet.[1] It is evident that Jaideva was well-versed in Sanskrit. Nabhadasa, an eminent saint of medieval India, referred to Hindu devotees in his famous composition *Bhaktamal* (literally, a garland of devotees) composed probably in circa CE 1578. In this composition he extolled Jaideva as an incarnation of lyric poetry. Jaideva himself referred to Kindubilva in the third canto of *Geet Govinda*:

> Hari's state is painted
> With deep emotion by Jaideva—
> The poet from Kindubilva village,
> The moon rising out of the sea.
> Damn me! My wanton ways
> Made her leave in anger.[2]

Each year in Kindubilva a fair known as Jaideva Smarak Mela is organized during mid-January to commemorate Jaideva. The tradition of singing *Radha Krishna Leela*, the divine play of Radha and Krishna, existed even before Jaideva and was sung in the ancient language of Prakrata. Even today, thousands of Vaishnava pilgrims visit this place and sing the *ashtapadis*, eight-stanza songs, of *Geet Govinda*. Near the bank of River Ajay in Kindubilva, there is a temple in which a square-shaped stone still remains. Legend has it that Jaideva used to sit on this stone during prayer.

Jaideva has not referred to his date of birth in any of his works. According to Bhartendu Harishchanda, Ram Rani Goswami, a descendent of Jaideva, surmised that he was born in CE 1108 (Samvat 1165) on the day of Vasant Panchami, the festival of spring. His father's name was Bhojdeva and his mother's name might have been Ramadevi or Radhadevi. Jaideva was a courtier of Raja Lakshamana Sen (also known as Lachchamania), the ruler of Bengal and the son of Ballal Sen. Both father and son were great lovers of art. The poets Gowardhanacharya, Umapatidhar, Sharan and Shrutidhar (Dhoyee) were contemporaries of Jaideva. Lakshamana Sen was himself a poet and wrote *Adbhuthsagar*. He requested Jaideva that he write great poem and this resulted in the *Geet Govinda* in CE 1148—a fact clearly indicated by Ram Rani Goswami. Since Jaideva was forty when he wrote the poem, it leads us to indicate the year of his year of birth as CE 1108.

It is said that Jaideva's parents were childless and they prayed to God to be blessed with a child. In answer to their prayers, God manifested himself in the guise of an ascetic and exhorted them to proceed to Puri to

offer their respect to Lord Jagannath. Obeying the instructions, the couple proceeded to Puri. It is said that Jaideva's father, Pandit Bhojdeva, composed a small poem, the opening line of which was *Jagannath Swami Nayanpath gami bhavatu me* (O Lord Jagannath, you are so powerful you enter me through the way of my eyes). He offered this prayer to Lord Jagannath and in due course of time, the Divine Light granted the solicited boon.

Nabhadasa mentions in the *Bhaktamal* that in his youth Jaideva was a wandering ascetic wedded to poverty, roaming about with a brass pot as his sole possession. He would not sleep under the same tree for two consecutive nights lest he get attached to it.[3] He visited many holy places and eventually reached Puri in Orissa where his life changed. Another legend says that Dev Sharma, a childless Brahmin, had been praying to Lord Jagannath for an offspring. The Lord granted his wish and a daughter was born to him, whom he named Padmavati. The father had pledged her to the service of the Lord. She grew up into a beautiful girl and Dev Sharma took her to the temple of Jagannath. The same night, God appeared in his dream and asked him to give his daughter's hand in marriage to His devotee Jaideva and they were married accordingly. Jaideva gave up his ascetic way of life and with Padmavati built a hut that had an image of Lord Jagannath. She followed him like his shadow. While she danced Jaideva beat the *mridanga,* a percussion instrument. In the first canto of *Geet Govinda,* Jaideva has referred to his ecstasy in these words:

Jaideva, wandering king of bards
Who sings at Padmavati's lotus feet,

Was obsessed in his heart
By rhythms of the goddess of speech,
And he made this lyrical poem
From tales of the passionate play
When Krishna loved Sri.[4]

Many legends have grown around the life of Jaideva. One of them is that while writing the tenth canto of the *Geet Govinda*, he was bewitched by a particular *shloka*, a verse. He came to the part where Krishna, in order to appease Radha, asks her to place her foot on his head. Feeling unwell, Jaideva left the verse incomplete and hastened to the river to take a dip. Krishna disguised himself as Jaideva and came to the rescue of his devotee. He went to Jaideva's home, ate of the food prepared by Padmavati for her husband, and completed the verse:

Place your foot on my head—
A sublime flower destroying poison of love!
Let your foot quell the harsh sun
Burning its fiery form in me to torment love.
Radha, cherished love.[5]

Padmavati, true to her form, ate the food which was left in the *thali,* plate. When Jaideva returned, he was amazed to see his wife eating before he did; for as a faithful and devoted Hindu wife, she never ate before her husband. Padmavati was also astonished to find her husband back home a second time. She discussed the earlier happening with him. They moved to glance at the poem which Jaideva had left incomplete and found the verse complete. They were both convinced that Lord Krishna himself had come and completed the verse. It was an hour of rejoicing for the couple.

It is also said that Gajpati Purushottamadeva, the king of Orissa, a poet and scholar, having heard the fame of *Geet Govinda*, composed another and called it *Abhinav Geet Govinda*. He ordered Brahmins to circulate copies of it. They, however, produced Jaideva's composition and declared its prominence. They added that a lamp could not compare with the sun. It was decided that the two books be submitted to the Lord for the light of His verdict. When the temple opened the next morning, the king's composition was seen resting on the floor.

It is believed that when Jaideva became too old to go to the bank of the holy river Ganga for a dip, Ganga herself moved to a well near his house. All these stories prove the popularity of Jaideva and his *Geet Govinda*.

The exact place and date of Jaideva's death is also controversial. Some say that Jaideva died in Kenduli and the last rituals were performed in Kenduli while some other scholars say that the *samadhi* or memorial, built on the cremation ground is not the *samadhi* of Jaideva but that of a *tantrik sadhu,* a devotee who performs rituals through meditative and sexual practices. Another version is that in the twilight of his life, Jaideva reached Vrindavana with the Banke Bihari idol of Radha and Madhava, received from Yamuna and died there. The exact date of his death is not known.

The Caitanya and Sahajiya sects regard Jaideva as the chief priest. The Caitanya sect was founded by Caitanya Mahaprabhu of Bengal in the 12th century. The followers of this sect were devotees of Krishna. They remembered Krishna by chanting his name. The Vaishnava sect emerged in the 13th century in India and considers Krishna as Uttampurush, or the first man.

There are several other poems, supposed to have been written by Jaideva. Two couplets in the *Gurugrantha Sahib,* the holy book of Sikhs, and a few in *Saduktikarnamrata* are also known as Jaideva's writings. He is also credited for the composition of a poem titled *Chandralok* and a play titled *Prasannaraghava.*[6]

Dr. R.C. Majumdar considers the poetry of Jaideva as the best specimen of complete harmony in the whole of Sanskrit literature. Quoting a prominent Sanskrit scholar he states, 'It has all the perfection of the miniature word-pictures which are so common in Sanskrit poetry with the beauty which arises, as Aristotle asserts, from magnitude and arrangement.'[7]

According to historical evidence, the Indian tradition of illuminated manuscripts goes back to the 10th century, but references regarding illuminations are found in many ancient texts, from the *Rig-Veda* to the *Ramayana,* the oldest Indian text and epic. The earliest illustrated manuscripts found are on palm-leaf and belong to the 10th and 12th centuries. Palm-leaf illustrations seem to have been widespread and have been found in Bihar, Bengal, Gujarat, Rajasthan and Karnataka. It is surprising that while we come across references of book illuminations in old Indian texts, we do not find concrete evidence to point to the same except a few Sanskrit, Jain and Buddhist works which were illustrated.

Karl Khandalavala is of the opinion that the earliest known manuscript illustrations in India are to be found belonging to the Pala period between the 8th to 13th centuries when Buddhism was in ascendancy. Palm-leaf manuscripts of eastern India towards the end of the 10th century CE are based on the late Ajanta style of painting, while in

western India the earliest illustrations are lightly coloured drawings. A palm-leaf Jain manuscript in the Jaisalmer Bhandar (temple library) dated CE 1060 shows some drawings of considerable merit.[8] Unfortunately, we have no evidence of manuscript illustrations from the south of India but it can be deduced that illustrated manuscripts might have been prepared even earlier. With regard to the pre-Mughal period, Khandalavala comments, 'It was not till the commencement of Lodhi rule in the Delhi–Jaunpur belt of northern India from A.D. 1451 to A.D. 1526 that we have any reliable evidence of Sultanate manuscript painting in India.'[9] He has mentioned several illustrated manuscripts that belong to this period such as *Laurchanda, Aryankparva of Mahabharata, Chaurapanchashika, Mrigavat* etc.

Dr. Pratapaditya Pal has elaborated upon certain illustrated manuscripts and leaves of the *Koran, Shahnama* of Firdausi (c. 940-1020) and *Khamsa* by Amir Khusrau (c. 1253-1352). Dr. Pal adds, 'It should be noted that the earliest surviving Koran in the Bihari script was copied in Gwalior, not far from Delhi in 1339, only a year after Timur's invasion.'[10] He has quoted Simon Digby who has provided evidence of paintings on paper and cloth. Several manuscripts were illuminated in the Deccan prior to the advent of the Mughals in India. It is also relevant to note that in Malwa, Mandu was a great centre of illumination during the pre-Mughal period. Manuscripts such as *Amrukshatak, Kalpa Sutra, Niyamatnama* and *Bostan* can be mentioned as examples of the art. Manuscripts were also illuminated in the Deccan.

In the later decades of 9th century, we find a fine tradition of miniature painting which flourished in Gujarat and Rajasthan. Early illustrated manuscripts such as *Kalkacharya Katha, Kalpa Sutra, Devasano Pado, Adi-purana, Pasanaha-chariu* etc. were produced in these regions.

In Bengal, the tradition of illumination existed in the pre-Mughal period. Dr. R. Dasgupta observes, 'For the first time, we find the growth of a national art in Bengal which enabled her to occupy a place on the art map of India. The form of this art book was illuminated manuscript on palm-leaves or paper, sometimes painted book covers. The majority of illustrated manuscripts are of the *Astasahasrika, Prajnaparmita*, those of the *Pancharksa* and *Mahamayuri* being rarely found.'[11] This was the first phase of illumination. The Mughal period, was a treasure of illuminated manuscripts. Under the patronage of Akbar, several Hindu texts were translated and illuminated, like the *Razmnama* (*Mahabharata*), *Ramayana, Anwar-e-Suheli* (*Panchatantra*) etc. Persian illustrated manuscripts, like the *Divan* (by Hafiz), *Gulistan* (by Sadi), *Khamsa* (by Nizami) etc. were also created under Akbar's patronage.

Akbar's tradition was not followed by his successors, as they were more inclined towards the execution of *murakkas* or albums. However, some illuminated manuscripts were executed, for example, *Padshahnama* which was illuminated under the patronage of Shahjahan. In the subsequent period i.e. the 16th to 19th centuries, many other manuscripts were illuminated. Some of the early Sanskrit manuscripts which were illustrated are *Bal Gopal Stuti, Vasant Vilas, Geet Govinda, Ramayana* and *Mahabharata*.

These examples indicate that the tradition of illumination of manuscripts commenced rigorously in India from the end of the 9th century onwards.

The earliest illustrations of the *Geet Govinda* date to circa CE 1450 and were found in Gujarat. A series of *Geet Govinda* paintings was done in CE 1590 in Jaunpur, in eastern Uttar Pradesh, now preserved in the Chhatrapati Shivaji Maharaj Vastu Sangrahalaya in Mumbai (formerly the Prince of Wales Museum). During the reign of Akbar, a manuscript of *Geet Govinda* was produced and in Bikaner it was illustrated by the artist Rukunnuddin. The Jaunpur manuscripts are the most important as they represent early features of the painting style which flourished in eastern Uttar Pradesh. The earlier Gujarat style was different from that of Jaunpur. The Jain texts point to the tradition of manuscript painting but there are also manuscripts like *Geet Govinda* and *Vasant Vihar* which are not Jain but have been illustrated. The *Geet Govinda* illustrated under Akbar's patronage is interesting as the Mughal influence is apparent on the costumes that the figures wear in these paintings.

In western Rajasthan, the *Geet Govinda* was painted in a modified Jain style in CE 1610. Under the patronage of Maharaja Sangram Singh II (CE 1710-1734), this magnificent poem was painted in Mewar in 1723. These paintings of the *Geet Govinda* are preserved in Saraswati Bhandar, Udaipur. In Kishangarh, a delightful series of paintings of *Geet Govinda* was produced in 1820 for Raja Kalyan Singh. During the reign of Raja Medini Pal of Basohli, the *Geet Govinda* was painted in 1730. The leaves are now dispersed but some of them are displayed in the Central Museum, Lahore; Punjab Museum, Chandigarh; and National Museum, New Delhi. Some leaves have also been preserved in private collections. The *Geet Govinda* painted in Kangra is simply exquisite. According to the colophon an artist named Manku[12] had painted it under the patronage of Raja Sansar Chand.[13]

Geet Govinda is the only Sanskrit poem that has been painted by artists of different representative styles of Indian miniature painting such as the Mewar, Bikaner, Kishangarh, Bundi, Kangra, Guler, Basohli etc. The *Geet Govinda* was painted in Malwa too in the latter half of 18th century. The leaves painted in Malwa style are in Kanodia Collection, Patna and Banaras Kala Bhawan, Banaras. Some painted leaves of this period are also preserved in the Scindia Oriental Institute, Ujjain.

Geet Govinda has been variously styled as a pastoral (Jones), a lyric drama (Lassen), a melodrama (Pischel), an opera (Levi), and a refined Yatra (von Schroeder). The story of this poem is limited to two-and-a-quarter days. The first day of spring centres on Krishna's love for other *gopis*, or milkmaids; the inquisitiveness of Radha; the regret of Krishna and the sadness of Radha. At night Krishna sends a *duti*, messenger, to Radha. The *duti* requests Radha to meet Krishna and to join the *rasa*, a dance, performed by Krishna along with milkmaids in the forests of Vrindavana but Radha is reluctant to oblige. She believes that Krishna must be frolicking with the *gopis* and gets annoyed. Thus, the night wears off. On the second day, Krishna tries his best to propitiate Radha but the latter gives him a rebuff. The *manini*, angry, Radha refuses to stoop. The whole day passes and evening comes. Krishna feels downcast and retires to his grove. Radha's *sakhi* or companion tries to cheer her up, urging her to go to Krishna's grove. Radha succumbs at last. The second night is the night of fulfillment of divine love. Next morning, Radha entices Krishna to set her apparel in order, with which the poem ends.

It is not a complicated or surprising story but the wonder lies in the lively and lyrical poem of Jaideva. All the *ashtapadis* of *Geet Govinda*

are elegantly arranged. There are twelve cantos, each of which contains one to four *ashtapadis*. At the beginning and the end of every *ashtapadi*, we find a *shloka* in the form of a benediction. The *ashtapadis* are suitable both for singing and acting.

The first canto, *Samodhdamodar* or Joyful Krishna, contains four *ashtapadis*—*Dashawatarvandana*, *Shripativandana* and two *Vasant Rasas* of Krishna. '*Damodar*' means 'one who is fearful' or 'one whose waist is bound'. Krishna is full of *samoth*, joy, because he is surrounded by the beauty and smell of spring. However, he is also fearful because Radha is absent. This is the internal monologue of Krishna. It is also ironic because this joy is like a candle that burns at both ends—neither Krishna nor Radha is satisfied. The second canto is *Akleshkeshava* or Carefree Krishna. It contains two *ashtapadis*. In first *ashtapadi*, Radha does not participate in the *rasa* but her heart belongs to Krishna. In the second *ashtapadi* of this canto, she implores her *sakhi* to do everything possible to keep Krishna around. The third canto, *Vimugdhamadusudana* or Bewitched Krishna, contains only one *ashtapadi* where we find a penitent Krishna pursuing Radha. The fourth canto, *Snigdhamadhusudana* or Tender Krishna, focuses on the forebodings of Radha as narrated by a *sakhi*, her solitary confidante. The fifth canto is called *Sakanshapundarikaksha* or Lovelorn Lotus-eyed Krishna. It contains two *ashtapadis*. In this canto, we find Krishna undergoing pangs of separation. He requests the *duti* to bring Radha to him. The sixth canto, *Kunthavaikuntha* or Indolent Krishna, contains only one *ashtapadi*. The *sakhi* persuades Radha to accompany her to meet Krishna but Radha is too weak to go out. The *sakhi* reports Radha's helplessness to Krishna. Radha goes into trance where she thinks she is going to meet her Lord but soon awakens to reality. At times, she imagines that she herself is Krishna. This canto is also known as *Utkantha* or *Sothkantha*; and one manuscript refers to it as *Dhanyavaikuntha*. The two *shlokas* of this canto delineate the mental condition of a *vasaksajja*, a heroine bejewelled and dressed, waiting for her lover. The seventh canto, *Nagarnarayana* or Cunning Krishna, contains four *ashtapadis*. At midnight when the moon shines over Radha, she becomes gloomy and sad. She puts many questions to her companion. She curses her. Several fancies flash across Radha's mind and she visualizes the frolics of Hari.

The eighth canto, *Vilakshayalakshmipatiha* or Abashed Krishna, contains only one *ashtapadi*. This canto begins with the description of the cursed night that Radha waited through but Krishna did not turn up. In the morning, she finds Krishna requesting her to accompany him to his grove. Radha remonstrates Krishna, as she is the *khandita nayika*, gloomy heroine. The ninth canto, *Mandamukunda* or Languishing Krishna, also contains only one *ashtapadi*. In this *ashtapadi*, Radha's companion requests her to meet Krishna. The tenth canto, *Chaturabhuja* or Four Quickening Arms, contains one *ashtapadi*. It shows Krishna's inquisitiveness. He is thinking about Radha's arrival in his grove. The eleventh canto, *Sanandadamodara* or Blissful Krishna, contains three *ashtapadis*. Elegantly dressed and bedecked with jewels, Radha proceeds to the grove of Krishna along with her *sakhi*. As soon as Radha reaches her destination, her *sakhi* disappears. The twelfth canto, *Supritpitambara* or Ecstatic Krishna, contains two *ashtapadis*. These *ashtapadis* highlight the union of Radha and Krishna and the poem ends with the sweet directives

of Radha to Krishna to be careful enough to restore her to her original appearance with her apparel and ornaments all in place. Radha no longer wants to retain her separate identity. She seeks to be one with Krishna.

At least 200 translations of the *Geet Govinda* are available in several Indian languages. Translations are also available in English, French, German, Latin, Dutch, Hungarian, Sinhalese and several other languages. William Jones first translated the *Geet Govinda* into English; which was published in 1792 and reprinted in London in 1799.[14] It was also translated into German in 1829 and Latin in 1836. Some early notable English versions are: the *Indian Song of Songs* by Edwin Arnold, published from London in 1875; George Keyt's *Sri Jayadeva's Geeta Govinda: The Loves of Krsna and Radha* published from Bombay in 1940; S. Lakshminarasimha Sastri's *Gita Govinda of Jayadeva* published from Madras in 1956; Duncan Greenless's theosophical work *Song of Divine Love*, also published from Madras in 1962 and Monica Varma's *The Gita Govinda of Jayadeva* published from Calcutta in 1968.

Barbara Stoler Miller's translation concentrates upon the cultural context. She recorded songs of the poem in different musical versions in Orissa, Bengal, Bihar, Chennai, Mysore, Kerala, and Nepal. Dr. Kapila Vatsyayan has done multidimensional research on *Geet Govinda*. Her great project *Geet Govinda and the Artistic Traditions of India* witnesses her long devotion of 35 years to this great Indian heritage.

Geeta Govinda had a deeper impact on Orissa as Jaideva was a great devotee of Lord Jagannath. He spent a major part of his life in the Jagannath Temple. About three hundred copies of *Geet Govinda* are preserved in the State Museum of Bhubhaneshwar. *Geet Govinda* was also carved on ivory in Orissa and the paintings were executed in Orissa on the different themes of *Geet Govinda*. The themes of *Geet Govinda* were also depicted by the artists on the basis of the different ragas and *raginis*, melodies. According to Bhartendu Harish Chanda, Raichand Nagar was the first man who translated *Geet Govinda* into Hindi at the behest of Raja Dal Chand in the 18th century. Swami Ratna Haridas of Amritsar translated it into Hindi in the early 19th century and Harish Chanda translated *Geet Govinda* during the last decade of the 19th century. There are also several other unpublished translations by various authors. The latest translation of *Geet Govinda* in Hindi prose is by Dr. Vidhya Niwas Misra, an eminent Sanskrit scholar, published in 1998.

It would be worthwhile to assess the impact of this unique creation on other branches of art. We find all the elements of the lyric in *Geet Govinda*. Jaideva made music on the basis of *Geet Govinda*—the kind even a commoner with no knowledge of Sanskrit could comprehend. The singing of *ashtapadis* is very popular even today, whether in the Jagannath Temple of Orissa or in the Khandoji Ashram at Kukurmunda in the remotest part of Khandesh.

During the annual spring festival at Kenduli, the birthplace of Jaideva, the singing of *Geet Govinda* is a holy tradition. In Nepal, the *Geet Govinda* is sung during the spring celebrations to honour Goddess Saraswati. In south India the poem is sung in accordance with the classical Carnatic form of music. It is also sung to accompany Kathakali performances in Kerala.

The last canto of *Geet Govinda* expresses Jaideva's real intent:
His musical skill, his meditation on Vishnu,

His vision of reality in the erotic mood,
His graceful play in these poems,
All show that master-poet Jaideva's soul
Is in perfect tune with Krishna—
Let blissful men of wisdom purify the world
By singing his *Geet Govinda*.[15]

In this *shloka*, Jaideva used the words *'Gandharva Kala Kaushal'* or the skill of Gandharva's art. On close scrutiny we find that Jaideva made music central to his poem. He experimented with it using *take* and *dhruwaka*, a 'refrain' repeated after each couplet. This experimentation made the *ashtapadis* of *Geet Govinda* very popular, as it did the singing of *Dashavatarcharita*, the story of Lord Vishnu's ten incarnations.

The dramatic element inherent in this poem is very effective. Jaideva's composition is a unique blend of *natha* or the musical voice which is a combination of voice and instrument and *nritya* or dance. The Indian tradition considers *natha* as God (Brahma in Indian tradition).

As *Geet Govinda* was a composition which inspired musicians, dancers, painters and litterateurs, there were also various commentaries on this great poem. There are two manuscripts in the Saraswati Mahal Library, Tanjore, which deal with the action to be performed on the basis of the verse. Similarly, in Kerala, there is a Malayalam manuscript which focuses on the dramatic performance of the *ashtapadis* by Kathakali dancers. In Manipur when the *Geet Govinda* is performed by Gamaka dancers, it represents four types of *rasa*. The *padas* or stanzas are sung in Brijbuli. Dr. Sunil Kothari, an eminent dance critic, is of the opinion that the composition of the *Geet Govinda* was intended only for dramatic

purposes. It is said that Jaideva used to play the *mridanga*, a kind of percussion instrument, and Padmavati used to dance to the *ashtapadis* of *Geet Govinda*. Besides these classical styles of dancing that comprised traditional performances, we also observe the tradition of Rasa dance in folk. In Khandesh, the tribal Abhirs perform Hallisak, which is a folk dance and can be classified as a form of *rasa*. Dance dramas on the *Geet Govinda* were also produced by Indian artists like Rukmani Devi and Mrinalini Sarabhai.

The popularity of the *Geet Govinda* is also reflected in architecture and sculpture. Bhartendu Harish Chanda has indicated that the verses of the *Geet Govinda* are engraved on the stairs of the Balaji Temple in south India. Neelmani Misra has made a similar observation about the main gate of the famous Jagannath Temple in Puri.

Classical poets like Kalidasa and Bharthihari wrote exclusively for an educated audience that was more or less conversant with the subtleties of the language. Jaideva, on the other hand, caters to a more diverse audience. Verses in the *Geet Govinda* express the poet's desire to reach an audience eager to aesthetically enjoy Krishna's divine love. The lyricism and dramatic contents of the poem might have been based on a non-classical form but Jaideva seems to integrated religious, erotic and aesthetic concepts which indicate that he sought to emulate Kalidasa's *Kumarsambhavam* and *Meghdutam*. Barbara Stoler Miller has minutely examined the details of the poem identifying 12 different syllabic metres. W.G. Archer comments, 'In this poem, Jaideva takes the Sanskrit tradition of courtly love poetry and applies it to Radha and Krishna. There is the same refined sensuality with its response to female charm.

Love, nature and the seasons are intricately blended. There is the old analysis of mood and situation. What is different is the investment of the chief actors with otherworldly status. Radha and Krishna behave as ordinary lovers. They exploit to the full the Indian art of love. They delight in each other's beauty and experience, a whole range of ardent emotions. But they are now distinct characters—they possess names—and behind their practices is the sanction of a great religious revival. Krishna is a *nayaka*, a lover, but because he is also God or Vishnu, sexual love and passion are regarded as life at its most sublime. Praise of lovemaking becomes praise of Krishna. Praise of Krishna involves praise of lovemaking.'[16]

The characteristics of a *nayika* or heroine elaborated in Sanskrit literature became synonyms of the characteristics of Radha, depicted by artists when they painted her. The *nayika* of Kishangarh style epitomizes all these characteristics: she possesses a gentle tenderness, girlish passion, kind solicitude and eager devotion; her eyes are large and delicate like a doe's; they flash like lightning; her face dazzles like the moon; her skin, limbs and hands are smooth and delicate like the lotus leaf; she looks like a lotus flower and her delicate charms lure the lover; her breasts are large and firm like pitchers of water and her hair is black as night and long as the tendrils of vine.

It is imperative to focus upon Radha, the key figure of *Geet Govinda*. In the tenth canto of the *Bhagvata Purana*, a religious Hindu text composed by Vedvyas during the 10th century, the Krishna *leela* is dwelt upon. But in this particular canto, we do not find any reference to Radha. The creation of Radha as a divine consort of Krishna seems

exclusively a concept of Jaideva. The literature and paintings pertaining to Radha after the 10th century bear out this fact.

Radha is a moment of eternal good; a great heritage of divine, eternal and immortal love. According to the Indian tradition, Radha is inevitably linked with Krishna. Both are dependent on each other. Traditional nomenclatures like Radha-Mohan, Radhe-Shyam, Radha-Vallabha, Radha-Krishna, vouch for Radha's precedence over Krishna. Although there is a reference to Radha in the *Rigveda* (3/33/12), Dr. Nilkantha Shastri, a commentator of *Mahabharata*, is of the opinion that this reference has nothing to do with Radha as we know her. Radha is defined in the *Amarkosh* as the full moon of Vaishakha Purnima;[17] love, affinity, the daughter of Vrashbhanugopa and beloved of Shri Krishna. In other dictionaries like *Shabdakalpadruma*, Radha is synonymous with *Vishakhanakshatra*,[18] *Vishnukanta*,[19] *Vidyutitibhedini*[20] etc. In *Nirukta*, a dictionary of Vedic Sanskrit written by Yask, 'Radha' means 'wealth'. In the *Bhagvata Purana* there is a *shloka* in which the name of Radha figures but this is not a familiar Radha. In *Brahmavaivartapurana*, there is an interesting interpretation of Radha which explains that 'ra' means 'to gain' and 'dha' means 'to leave'—making it the only name which involves two opposites. In the religious *Puranas*, there are several references and interpretations of this word. In the *Upanishads*, we do not come across many references to Radha except in *Radhikopnishada* and *Radhikatapniyopanishada*. In the former she is considered the power behind Hari and in the latter she is addressed as the most beloved of Krishna. But these *Upanishads* belong to the 17th century and do not provide much conclusive evidence. Clear references to Radha are found in

three *Puranas—Padam Purana, Devi Bhagvata* and *Brahmavaivarta*. In the *Matsya Purana*, also there is a *shloka* which records the name of Radha. In *Brahmavaivartpurana*, there are several references and observations about Radha. According to Dr. Hajariprasad Dwivedi, an eminent scholar of Hindi and Sanskrit, this *Purana* belongs to the 13th or 14th century.[21]

Dr. Hajariprasad Dwivedi argues that Radha might have been the goddess of Abhirs, related to Balkrishna. In the course of time Balkrishna would have merged with Vasudeva Krishna, which is why we have no reference to Radha in Aryan literature. Dr. Shashibhushandas Gupto, an eminent scholar of linguistics and former Head of Modern Languages, Calcutta University, has established that *shakti tatva,* the element of power, formed the basic element of Radha. Dr. Baldeva Upadhyaya opines that Radha stands for *aradhana, archana,* or *archa* meaning 'prayer'. Charlotte Vaudeville sums up the attributes of Radha saying, 'Radha herself, in indissoluble union with Krishna is worshipped as his *ahladini-sakti,* his power of joy or blessedness, and she is represented with the bright, golden complexion usually attributed to Durga.'[22]

Dr. Rammurti Tripathi, an eminent scholar of Hindi and Sanskrit, ascribes the emergence of Radha to *tantra,* scripture dealing especially with the technique and ritual including meditative and sexual practices. He has referred to the *Narad Panchratra,* a text of *tantra* wherein Radha figures vividly. There are a host of references to Radha in the *Gathasaptashati* of Hal, *Panchatantra* of Vishnu Sharma, *Dashrupak* of Dhananjaya, *Dhwanyaloka* of Anandwardhan and *Venisamhara* of Bhattnarayana. Kshemendra and Bilhana, the predecessors of Jaideva, have also cited references to Radha in their compositions, *Dashawatara* and

Vikramankdevcharita. Bajjalagga, a Maharashtrian Prakrata text alludes to Radha. Radha finds due place in Jain studies by Jainacharya Hemchandra (1089) who narrated the seclusion of Radha in his work on grammar.

There are also a few archaeological evidences that point to Radha.. Dr. K.D. Vajpai, the renowned archaeologist, has stated that the images of Radha in stone, clay, metal, ivory and wood dating from CE 1200 to 1700 have been found scattered over different parts of India. Radha's images dating to the same period are also found in different temples in Nepal.

Barbara Stoler Miller considers Radha one the most obscure figures in early Indian literature. Miller finally concludes 'the character of Radha in the *Geet Govinda* established her as Krishna's consort within later traditions of Krishna cult. Her relative obscurity in earlier literature encouraged the view that the Jaideva invented Radha. Although, he clearly did not invent her, he did create a unique heroine for Indian devotional literature.'[23]

There is no direct evidence about the historicity of Radha. Scholars have based their findings on the old Sanskrit, Apbhransha and Prakrata texts. In the texts predating Jaideva, like *Venisamhar* of Bhattnarayana (CE 750), *Dhwanyaloka* of Anandwardhan (CE 850), *Saraswatikanthabharan* of Bhoj (CE 1066) and *Dashawatarcharita* of Kshemendra (CE 1066). The *Nalchampu* of Trivikrambhatt (10th century) and a Prakrat text named *Pingalsutra*, deal with the frolics of Radha and Krishna.[24] Two inscriptions dating to the 10th century found in Dhar cite Radha as the beloved of Krishna. An image of a woman playing on a flute, said to be Radha, was also found in the excavations at Mathura. The sculptures

excavated from Suratgarh and Paharpur have also been identified as Radha. With regard to the tradition of painting, the depictions done in different styles belong to a later age. These depictions were produced after the 13th century and do not provide any historical evidence of the emergence of Radha.

Jaideva largely benefited from the various concepts of his predecessors and endowed Radha with a unique personality. Following suit, several sects—Nimbark, Sakhi, Gaudiya, Shrivallabh, Vallabh, Radha-Vallabh, Vaishnav Sehjiya, Madhwa, Nijananda (Pranami), Haridasi and others devised new concepts and distinctive forms of worshipping Radha.

During the medieval age, we find the influence of mysticism on Indian literature. The Bhakti cult ushered in a new era of devotional literature. The Alawar saints of the south were the true representatives of the emotional surrender which is known as Bhakti. Medieval Bhakti poetry is full of divine love, depicting the nuances of Krishna *leela*. Radha occupied centre stage and numerous poems were composed, particularly in Brijbhasha. *Nayak-nayika bheth*[25] dealt with literature and paintings by the artists. This theme was usually based on the love of Radha and Krishna. The *Ritikala*[26] of Hindi literature is also known for love poems. Keshava, Bihari, Matiram, Padmakar and several others wrote poems like *Rasik Priya, Kavi Priya, Bihari Satsai;* brimming with *shringara.*[27] These poems together with Radha-Krishna provided inspiration to medieval and later medieval artists. Madhura Bhakti, one of the dimensions of Bhakti, became very popular and devotees sought emancipation through this Bhakti cult. Kanta Bhakti, was yet another dimension.

In the literary domain we find hundreds of poems primarily based upon Krishna *leela* written almost in all the Indian languages. There are also prose works, both published and unpublished in other Indian languages. The wave of Vaishnavism[28] also promoted the Radha cult. Radha is loved and worshipped by the people of Brij as their divine daughter or Lali of Barsana on the one hand and on the other, as the *alhadini shakti* or the supreme power of Krishna. Sanskrit, Prakrata, Apbhransha, Marathi, Tamil, Orissi, Assamese, Bengali, Punjabi, Gujarati, Malayalam, Kannada, Telugu and Hindi are the main languages in which we have fine compositions on the theme of Radha. In languages like Maithili, Bhojpuri, Avadhi, Malwi, Nimadi and Khandeshi, there are numerous folk songs, still sung by the masses.

This narration of Radha's story establishes how a concept develops and eventually becomes the eternal source of inspiration and devotion. Dr. Shashibhushandas Gupto traces the origin of Radha from the Shakti cult; Dr. Baldeva Upadhyaya, Dwarikaprasad Meetal and several others discover the origin of Radha in the ancient texts. In recent times, Dr. Vidhya Niwas Misra has also followed the same line of thought and he considers Radha a great symbol of emotion and sentiment. He considers historical Krishna as Bhavpurusha Shrikrishna. Krishna as Bhavpurusha means an incarnation of emotion or sentiment. Dr. Misra's monumental work *Radha Madhava Rang Rangi* is also an excellent addition to modern Hindi literature. Radha and Krishna are not two separate entities. Krishna is incomplete without Radha and Radha is the essence of Krishna.

There is a popular legend concerning the image of Banke Bihari enshrined in Banke Bihari Temple in Vrindavana. (Banke Bihari is the

appellation given to Radha and Krishna when presented as a couple.) The legend says that Radha and Krishna were dancing on each palm of Swami Haridasa[29] when the palms came together and thus they merged into each other. It is believed that when a person goes for the *darshan* or glimpse of Banke Bihari, he first finds Krishna and then Radha before his or her eyes.

The depiction of Radha in the tradition of Indian miniature painting does not follow a chronological sequence. In the Mughal *kalam* or style of painting, the theme of Radha and Krishna was painted, yet fine miniatures were done later in Rajasthan and Himachal Pradesh. There are a hundred miniatures belonging to the last decade of the 16th century in the collection of N.C. Mehta, an ICS officer and eminent art critic of Indian miniatures. They bear the trademarks of the Gujarati style. Later on, the Rajasthani and Pahari artists worked wonders with their brushes.

These artists were inspired by devotional piety which is reflected in their paintings. They have used the colour blue for Krishna as the symbol of life. In Mewar, Jaipur, Jodhpur, Bikaner, Bundi, Kota, Devgarh and Kishangarh, hundreds of paintings were based on this theme. During the reign of Raja Jagat Singh (1628-1652) and that of his successor Rana Raj Singh (1652-1680), we perceive a marked improvement in the Mewar style. At about the same time in Nathadwara fine miniatures were being painted. *Rasik Priya* and *Sur Sagar* were also themes for paintings. A series of paintings based upon the *Brahmar Geet*, a classic poem of Parmananddasa of *Asthachhap* genre[30] are particularly interesting. In these we get an enchanting depiction of lovelorn Radha as they have poignant expressions of loneliness and seclusion.

Bihari Satsai[31] was also painted. The artists used line and colour to bring out the emotions of the Bihari couplets. They brought alive the atmosphere of Vrindavana with its green gardens, orchards, dense clouds, cranes floating in the River Yamuna, the lotus flowers and the *kunjas* or groves where Radha and Krishna performed their *leela*.

In Mewari miniatures, Radha takes part in a play. In the collection of Gopi-Krishna Kanodia in Patna, there is a fine miniature in the Mewar style based on raga *vasant* or spring. Krishna is depicted as playing on his flute and Radha sits before him with covetous eyes. Her locks are as black as night and her pearl jewellery can be seen. She has arched eyebrows, a sharp nose and doe's eyes. Her painted lips look like the petals of a lotus. She wears a transparent azure sari draped around her. It is almost as if one can read the language of the eyes.

In the collection of Kunwar Sangram Singh of Navalgarh, we have several miniatures centered on Radha. One of the miniatures significantly depicts the *manabhava* or the anger of Radha. The Kishangarh style has universal appeal. Nihalchand who depicted Radha as *bani thani*, a well-dressed heroine wearing ornaments, is famous all over the world as he depicted all the classical characteristics of an ideal heroine portrayed in Sanskrit literature in this painting. Nihalchand and his predecessors have painted several scenes of the Krishna *leela*. A boat scene in the Kishangarh style is preserved in National Museum, New Delhi. The boat scene is famous among art lovers and was painted by Nihalchand in the 18th century. The boat on the surface of Gundalo Lake of Kishangarh, the divine couple, and the flora and fauna are beautifully painted. Krishna is shown seated with Radha in a boat, advancing towards her. The

Kishangarh artist has followed the classical Indian tradition. The face is not round but of proportionate length. The nose is long, the eyebrows round, and the neck is like a *surahi,* an earthen pot, the upper part of which is long and narrow and the lower part round.

There are depictions of *Sanjhi Leela,* a play by the members of the royal families in their palaces. In a particular scene, Radha is sitting on a throne with her four confidantes standing guard. Since no male was allowed, Krishna stands before Radha disguised as a *sakhi.* This depiction of Radha is superb. She is painted as a tender heroine having every feature of a classical *nayika* of Sanskrit literature.

Likewise, in the Bundi-Kota style, we have depictions of several scenes mostly painted after CE 1590. During the 17th century, *Geet Govinda, Rasik Priya, Barahmasa, Bhagvat Purana, Ragmala* and the poems of Surdasa were exquisitely painted. Radha is the focal point of these paintings. In the following century, this *kalam* bears the stamp of other styles of Rajasthan like Mewar and Nathadwara as well. Here, Radha is depicted dancing, singing, and waiting for Krishna. In the Jaipur *kalam,* we see fascinating facial renderings of Radha, portrayed as having dark, wide, penetrating eyes and wearing costumes painted in contrasting colours.

An artist named Rukunuddin, who belonged to the Mughal court, came to Bikaner by the end of the 17th century and painted with excellent skill miniatures of Krishna *leela.*

In the Devgarh *thikana,* a small principality, smaller than a kingdom, an artist named Chaukha painted Radha with excellent skill. Chaukha is at his best in a twilight scene showing Krishna returning home with his cows. Radha is shown as eagerly awaiting her cowherd. All these miniatures are preserved in Chhatrapati Shivaji Maharaj Vastu Sangrahalaya, and in the collection of Rawat Nahar Singh II of Devgarhas.

The traditional hill states have Kangra, Guler, Mandi, Chamba, Basohli, Bilaspur and Garhwal as the chief representative styles. In all these, Radha's beauty is perfectly portrayed. Powerful poems like *Rasmanjari, Geet Govinda* and *Rasik Priya* inspired the artists to depict Radha. The *manbhava* painting of Radha almost brings her to life.[32]

Under the patronage of Manku, several paintings of Radha were produced in Basohali style in CE 1730. There is a captivating miniature in Bharat Kala Bhawan, Banaras that pertains to the Chamba *kalam.* There is also an excellent painting made between 1765-1770 done in the Bilaspur idiom and preserved in Indian Museum, Kolkata. In this strange miniature, Radha appears in police uniform, arresting Krishna. The bewildered *gopis* gaze at Radha and Krishna. Radha looks stern like a constable in true form.

Molaram, an eminent artist of Garhwal has depicted Radha in all her exquisite charm, grace and delicacy, seated or standing under a flowering *mandara* tree. The miniatures of Radha in this particular style are preserved in Bharat Kala Bhawan, Banaras, in the collection of Barrister Mukundilal; Lucknow Museum, Boston Museum; and National Museum, New Delhi. There are also fine miniatures of Radha in the Malwi and Bundelkhandi style too.

During the period of Maratha hegemony, fourteen miniatures were found from the Pandrinath Temple in Maheshwar, once the capital of the

illustrious Maratha ruler Ahilya Devi. In these miniatures, Radha is made up to look like a Maratha lady. In 1660, Sukhdeva painted miniatures in Malwa idiom. They are based on the *Rasabeli* of the poet Puhukar who composed poems focusing the acts of heroes and heroines. In several ragas and raginis, Radha is painted in the Malwa idiom.

Holi festivities were also a popular form used for the depiction of Radha. There is a miniature in the Indian Museum, Kolkata, painted in 1780, showing Radha and Krishna sprinkling coloured water on each other. Such scenes were also portrayed in Mughal, Deccani, Amer, Mewar and Bikaner *kalam*.

To view these miniatures is indeed a magic experience, a journey into the path of divine love of Radha and Krishna through the medium of colours and lines. It is indeed a unique manifestation of the ardent devotion of the gifted artists of India. Their creativity has never been surpassed.

1 Barbara Stoller Miller, *The Gita Govinda of Jaydeva: Love Songs of the Dark Lord* (Delhi: Motilal Banarsidass, 1977), 3.

2 Ibid., 84.

3 M.S. Randhawa, *Kangara Paintings of the Geet Govinda*, 2nd edition (New Delhi: National Museum, 1982), 42.

4 Barbara Stoller Miller, *The Gita Govinda of Jaydeva: Love Songs of the Dark Lord* (Delhi: Motilal Banarsidass, 1977), 69.

5 Ibid., 113.

6 Bhartendu Harishchanda has referred to other compositions by Jaideva in his monograph but does not provide any historical evidence.

7 R.C. Majumdar, ed., *The Struggle for Empire*, Vol. 5 of *The History and Culture of the Indian People* (Bombay: Bharatiya Vidya Bhawan, 1966), 303.

8 Karl Khandalavala, *Paintings of Bygone Years* (Bombay: Vakils, Feffer and Simons Limited, 1991), 1.

9 Ibid., 2.

10 Pratapaditya Pal, *Indian Painting: A Catalogue of the Los Angeles County Museum of Art Collection* (Los Angeles: Los Angeles County Museum; Ahmedabad: Mapin Publishing Pvt Ltd., 1993), 27, 154.

11 R. Das Gupta, *Eastern Indian Manuscript Painting* (Bombay: D.B. Taraporewala Sons and Co. Pvt. Ltd., 1972), 29. The quote has been grammatically corrected.

12 Manku is a controversial figure among art critics. Some scholars are of the opinion that Manku was a royal lady under whose patronage the paintings were executed in royal atelier. Some others are of the view that Manku was a male painter. However, even if he was a painter, he would have been the leader of the group of artists. Dr. W.G. Archer has thrown light on this controversy in M.S. Randhawa's book *Kangra Paintings of the Gita Govinda*.

13 Maharaja Sansarchand (r. 1777-1823) and it was under his patronage that that famous Kangra *Geet Govinda* was executed. The great artist Manku/Manak/Manaku is given credit for the execution of this set. Some other sets of the *Geet Govinda* were also executed. Purkhu, an eminent Pahari artist, also executed the paintings of *Geet Govinda*. M.S. Randhawa's study was based on leaves from the collection of Maharaja Manvindra Shah of Tehri-Garhwal. There are several leaves

painted by other artists on the same theme. These leaves are now dispersed and preserved in the different museums or in private collections. Some prominent museums where these paintings are preserved are: National museum New Delhi; Bharat Kala Bhavan, Banaras; L.D. Institute, Ahmedabad; Picture Gallery, Vadodara; Chandigarh Museum; Binney Collection of the San Diego Museum of Arts; The Los Angeles County Museum of Art; The Brooklyn Museum and the Museum of Fine Arts, Boston. The Victoria and Albert Museum in London also has some superb leaves of the Kangra *Geet Govinda*. Some private collections where the leaves of the Kangra Geet Govinda are preserved are the Goenka Collection, Kanodia Collection and the Jennifer Bellak Barlow Collection.

14 The translation was published in *Translations of the Asiatic Society*, Calcutta, and reprinted in London in *Asiatic Researches, 3* (1799): 185-207.

15 Barbara Stoller Miller, *The Gita Govinda of Jaydeva: Love Songs of the Dark Lord* (Delhi: Motilal Banarsidass, 1977), 125.

16 W.G. Archer, *Love Songs of Vidyapati* (Delhi: Motilal Banarsidas, 1987), 25.

17 The full moon night of the month of April.

18 A constellation.

19 Goddess Lakshmi, wife of God Vishnu.

20 Like lightning; having the power of penetration.

21 Hajari Prasad Diwedi, *Hindi Sahitya ki Bhumika* (Delhi: Rajkamal Prakashan, 1991), 187.

22 John Stratton Hawley, *The Divine Consort: Radha and The Goddesses of India* (Boston: Beacon Press, 1982), 2.

23 Barbara Stoller Miller, *The Gita Govinda of Jaydeva: Love Songs of the Dark Lord* (Delhi: Motilal Banarsidass, 1977), 37.

24 Shri S.K. Bhattacharya argues unconvincingly that, 'Radha is mentioned in the *Brahma Vaivarta Purana* for the first time in the literary history of Krishna's cult. He has dated *Brahma Vaivarta Purana* to the 9th century. *Rooplekha*, Vol. XXX, No. 1&2 (July 1959): 23.

25 'Nayak' means hero and 'nayika' means heroine. Sanskrit literature defines different types of heroes and heroines. Poets and art critics have made distinctions among the types of heroes and heroines and minutely explained their characteristics which have been delineated in literary compositions and in the critical appreciation of paintings.

26 Medieval poets in the 16th to 18th centuries considered Krishna as the hero and Radha as the heroine, and accordingly wrote the verses in which they narrated the characteristics of hero and heroine. This period of love poetry is known as *Ritikala*.

27 *Shringara* is the full expression of beauty manifested in makeup and ornamentation.

28 Vaishnavism is a doctrine and also a cult. Mahaprabhu Vallabhacharya, a great medieval saint and follower of Krishna, was a great Vaishnava saint. He was a devotee of Shrinathji and enshrined an idol of Shrinathji (brought from Brij) in Nathadwara. A great wave of Vaishnavism spread in north India in medieval period.

29 Swami Haridasa was a great musician and the guru of Tansen, one of the 'nine jewels' of Akbar's Court. Akbar wished to see Swami Haridasa, who refused to visit his court. Akbar then asked Tansen to mediate and Tansen accompanied Akbar to Vrindavana to see Swami Haridasa.

30 'Astha' means eight. There were eight poets in the medieval period who where followers of Vallabhacharya, a great Vaishnava saint. They wrote verses praising Krishna. Surdas, Parmananddas and Kumbandas were the most famous. As they were eight in number, they were known as the poets of *Ashtachhap*.

31 Like Keshva, Biharilal was a great medieval poet. He wrote Hindi couplets praising Radha and Krishna's love. He also wrote Hindi *duhas* or couplets about *nayak-nayika bhed*. 'Satsai' means one hundred. The hundred couplets of Bihari are known as *Bihari Satsai* in Hindi. The themes of these couplets became the source of inspiration for medieval artists of medieval times.

32 Radha becomes silent and lives in seclusion when she is angry with Krishna. This state is called *man* which means anger. There are fabulous paintings of Radha's *manbhav* in the tradition of Indian miniatures. The most popular painting of Radha's *manbhav* is in the Chhatrapati Shivaji Maharaj Vastu Sangrahalaya, Mumbai. It is executed in the 18th-century Kangra style. In this painting the body of Radha, twisted due to anger, has been minutely depicted by the painter.

The Kanheri Geet Govinda

The *Geet Govinda*, which I chanced upon in Dhule, belongs to the region of Khandesh in India (see map on page 7). According to Abul Fazl the name 'Khandesh' is derived from the word 'Khan'—the title conferred upon Muslim Farukhi rulers. The fact that Ferishta refers to the Muslim chiefs of Khandesh in his account of the first Muslim conquest in CE 1294 supports the view that Khandesh, though it might have been known by another name, existed prior to the Muslim conquest. C.S. Sinclair has suggested that Khandesh was originally the land of Krishna or Kanha. Rao Saheb K.B. Marathe opines, on the basis of some ancient verses, that Khandesh is in fact the Khandava forest mentioned in the *Mahabharata*.

On the other hand, Col. Sykes argues that Khandesh is derived from the word 'khand' or 'khind', which means 'gap' or 'mountain pass'. Dr. Shivaji Devre has thoroughly researched the Rasa literature of Maharashtra, especially the folk tradition. He has made some interesting observations. The word 'Khandesh' is also considered a derivative of 'Khandava Desh', where the Pandavas stayed while in exile.

Many of these presumptions have no basis at all. It is a historical fact that 'Khan' was the title of the Farukhis who dominated this area. However, Dr. Ramkrishna Bhandarkar refers to the Abhirs, the votaries of Gopal Krishna[1] who predominated over this region and popularized the Krishna cult. Since Krishna worship flourished in this region from the earlier times, it can be deduced that the region came to be known as Kanha Desh. It was only after the Muslim conquest more so after the Farukhi domination that Kanha Desh turned into Khandesh.

The oldest Khandesh legends are connected with the hill forests of Turanmal and Asirgarh. The *Mahabharata* mentions Yuvnashva, the ruler of Turanmal who fought with the Pandavas. According to local legend, Asirgarh had been the headquarters of Rajput chiefs who had migrated from Oudh during circa 1600 BCE.

In early times Khandesh, like the rest of Deccan, was probably under great vassals and landholders who held sway over the areas of Asirgarh, Nasik, and Laling. The rock-temples, found in Khandesh, show that during 200 BCE to CE 300, Khandesh was under rulers who patronized Buddhism. An inscription found in Nasik dating back to CE 419 mentions an Abhir king named Veer Sen. The Abhir kings dominated Khandesh for about 175 years and influenced the life of people. Their language was Abhiriani. There are several references to Abhirs in the *Mahabharata* and in the *Puranas*. In *Skandhapurana*, they are referred to as tribes living on plunder. In *Kumarpalcharit* of Jaisingh Suri written in CE 1256, it is stated that the Chalukaya king of Anhilwad crossed the River Narmada and captured the capital city Akashnagari, which was the capital of Abhirs.[2] Akashnagari is presently known as Prakashgaon or Prakasha in the district of Shahada Tehsil. Abhirs or Ahirs are mostly shepherds and herdsmen. One of the sub-castes of Ahirs is known as Mathurawanshi and people belonging to this caste are followers of Lord Krishna.

It is evident from the inscriptions and old historical texts that the Abhirs and Ahirs dominated over Khandesh prior to the 13th century. They were the worshippers of Lord Krishna. It is equally evident that they had migrated from the north and settled in down Khandesh.[3]

In the light of above data, it is seen that Khandesh was the region where the followers of Krishna ruled and promoted Krishna worship.

During medieval times when Muslims had seized power, the name Kanhadesh changed to Khandesh. Kan Bai, associated with Krishna, is a popular deity of this region and this fact leads credence to the popular belief that the original name of this region was Kanhadesh.

The transformation of Radha vis-à-vis Kan Bai, began slowly. Kan Bai, Kanha Devi and Moga Devi are just simple transformations of Radha. In a village called Dev Mogra in Shahada Tehsil, two small sculptures stand in the Mogadevi Temple. The metal sculpture is called Moga Devi or Kalimata. This is probably an image of Radha since the idol holds a *matki*, pot, in her hands. The other sculpture is that of Krishna, which is easily identified.

The local people, particularly the Patils, even now sing the verses of *Geet Govinda* in the regional dialect. The Rasa dance tradition continues in a dance called Hallisak performed in Khandesh. The tribals of the village gather together at night, around a wooden pillar. They form a circle and dance, emulating in their own way the famous Rasa dance of Brij.

The tradition of preserving *Geet Govinda* manuscripts also continues in Khandesh. One of these is in the possession of Shri Triyambak Shastri, aged 75 years. He has had the *pothi*, manuscript, has in his family for four generations. Dr. Shivaji Devre has provided a detailed list of manuscripts, which he found in Khandesh. These manuscripts are in a language which is a blend of Brij and the local language. The verses include conversations between the *duti*, messenger, and Radha; and the *duti* and Krishna. A comparison between these verses and the *ashtapadis* of *Geet Govinda* makes clear the similarities between the two. A unique

tradition endures in Khandesh that when these *pothis* become old, they are submerged in a river and are rewritten afresh.

The illustrated manuscript of *Geet Govinda*, found in Dhule, is said to have been painted in Prakasha, which is located on the bank of the River Tapti and has as many as 104 temples.

Prakasha was earlier known as Akashnagari. It was also known as Prateek Kashi, or 'symbolic Kashi', since the indigent masses could not afford to go all the way to Kashi for a *darshan*, glimpse, of Vishvanath. In the course of time, Prateek Kashi changed into Prati Kashi, and is now called Prakasha. I was informed by the officials of Samarth Wagdevta Mandir that they had no knowledge regarding the illustrated manuscript of *Geet Govinda*, which was discovered by Shri Krishna Dev. The history of this *mandir*, temple, is quite old. Shri Shankar Shri Krishna Dev, who was also known as Nana Saheb Dev, founded it in 1935. He was a political and social activist and a lawyer by profession. He was a follower of Guru Samarth Ram Da, a great saint of his times, the mighty Guru of Shivaji and the author of *Dasbodha*. Shri Dev established Satkaryottejaksabha in 1892. In 1935, this Sabha was known as Samarth Wagdevta Mandir i.e. the temple of the god of learning. It is also, in fact, a museum where several art objects and manuscripts are preserved and is used as a library. An idol of Ramdasa which is worshipped by visiting scholars is enshrined in the library. More than 10,000 manuscripts are preserved in the temple and out of these 3,500 catalogued manuscripts have been numbered. The *Geet Govinda* bears 'bad' number 2234.

The illustrated *Geet Govinda* contains 290 miniatures. Two folios have not been illustrated. Each illustration has a suitable Sanskrit caption.

The last miniature bears the colophon below:

Temburanpure Likhitam Raghav Ramen
Shri Sadashivam Diyate Kshetram Prati
Samvatsar 1822 shake 1687 Parthiv Naam
Samvatsare Hemant Ritu.

This indicates that the illustrations of the *Geet Govinda* go back 236 years. It is obvious that it was completed after execution in CE 1765. The paper, which is used for the preparation of manuscript, was found, after minute examination, to be more than 200 years old.

Another illustrated *Geeta* Govinda executed in the style was also found in the Samarth Wagdevta Mandir. This *Geeta Govinda* is also quite old. It is quite likely that both the manuscripts were illustrated simultaneously by the same set of artists. A notable point about the colophon is that there is some rewriting over the text. After thorough examination, it could be deduced that rewriting was done to rejuvenate the original text. There is no rewriting on the recorded years of execution.

No substantial information regarding Raghav Ramen, who is mentioned in the colophon, is available in spite of exhaustive attempts to trace his history or lineage. Sadashiv Kshetra, also mentioned in the colophon, is undoubtedly Prakasha, which other religious sources have verified. Temburanpure is also untraceable. It may be assumed that this manuscript might have been illustrated somewhere else and then brought to Prakasha, because the colophon speaks about a *prati* or copy. It is possible that other illustrated manuscripts were prepared and copies of them sent or brought to the holy places. '*Temba*' is a Marathi term,

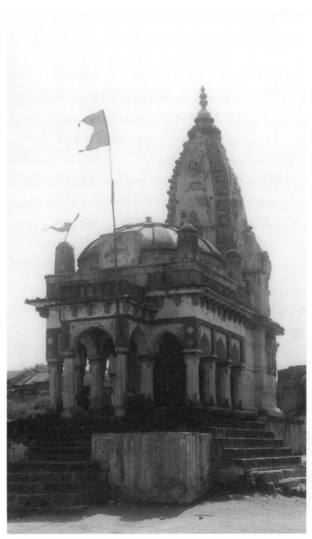

Shiva temple of
Prakasha

which is used for a small village. On the basis of the available material, it is probable that local and Rajasthani artists located in Prakasha or around Prakasha illustrated this manuscript.

The main feature of this *Geet Govinda* is that it is complete. One of the rare characteristics of this illustrated manuscript is the portraying of ragas and *raginis*. Gurjari, Basant, Ramkali, Karnataka, Deshakh, Deshi Waradi, Bhairava, and Vibhas are the *ragas* and *raginis*, depicted by the artists. Another significant feature of this manuscript is that eight cantos possess couplets of good wishes in the end. These couplets are not found in other manuscripts. There are nine *shlokas* in this manuscript which make it different from others of its kind. A couplet refers to the name of a poet

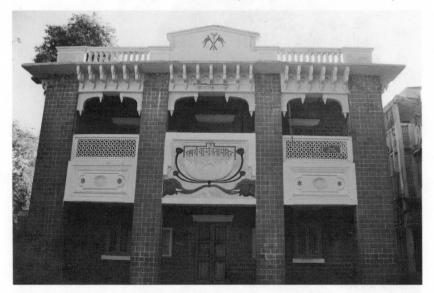

Samarth Wagdevta Mandir, Dhule

Kavindra Ravindra. It can be deduced that the inscribers and artists might have incorporated these couplets. The miniatures are executed on the basis of these *shlokas*. Every *ashtapadi* is tastefully painted in the Kanheri style.

It seems possible that the local artists opted to paint the local style of dresses, jewellery, flora and fauna while the Rajasthani artists preferred to paint the delicacy of the figure and facial expression. The absence of the application of rare and precious colours indicates that the artists used local colours, mainly vegetable and pigments obtained from minerals. Indigo is frequently used in painting the sky and Krishna. The choice of colour seems to follow Mewar and Nathadwara patterns. The artists seem to have adopted the traditional method for executing the miniature. *Tipai* follows *sachchi tipai*—light and shade modelling comes first, followed by the final outline and colouring. They do not seem to have used gold or silver. These characteristics have imparted a unique regional flavour to the miniatures.

The drawings show the perfection of the line, and the treatment of colours is noteworthy. In some depictions of Radha, the face is round. The frontal depiction of face shows an imbalance of lines in some miniatures. Some miniatures represent the joint venture of the local and Rajasthani artist. The Rajasthani artist depicted Radha in a manner identical to that of the Mewar and Malwa schools. Historically, Khandesh had a close relationship with Rajasthan. The King of Jaipur visited Dhule, and according to tradition, would have been accompanied by the artists. The influence of the Mewar school is also clear as is the influence of Nagpuri style of the later medieval period. The thin birds represent the main

feature of this style. The miniatures, based on the theme of *Ramayana* which are preserved in National Museum, New Delhi, are identical in several respects to these miniatures. Apart from the toy-like birds, the flora and fauna painted in Nagpuri miniatures, is also quite similar to those of the Kanheri *Geet Govinda*.

These miniatures do not possess the delicacy and ornamentation of the pictures executed in a royal atelier but they show an originality of style and execution.

These miniatures can be categorized into those influenced by the Nathadwara, Jaipur, Mewar, Alwar and Malwa schools and those that show an amalgamation of styles resulting in a Khandeshi or Kanheri style.

The female figures that belong to the first category wear a *lehnga*, or skirt; and *chunni*, or veil. They wear Khandeshi as well as Rajasthani ornaments. *Nath*, nose ornament; *karnaphool*, earrings and *chudis*, bangles are common features. The size of the *nath* is abnormally big, which is one of the specific characteristics of Khandesh. In some miniatures a *mathapatti*, an ornament for the forehead, can be seen. The size of the *karnaphool* is also big and the number of *chudi* or bangles is more than what is usually depicted. The women are shown wearing ornaments symbolic of married women such as *mangal sutra* and *payal* or anklets. In Khandesh, women paint a longer red mark on their forehead, which is known as *khor* or *malvat*. In several miniatures we find figures of women with a *malvat* on their forehead. This is a composite feature of the Rajasthani and Khandeshi style. The profiles are identical to the Mewar and Malwa schools. Some female figures are shown wearing a high *juda*, lock of hair, a significant feature of Jaipur and Bundi.

The male figures in this first category are tiny, their faces are round, noses longer, bodies bulky and are shown wearing *dhoti*, loose garments for the lower body and a *dupatta* or scarf. Their tied hair, called *choti*, is identical to those of Goswamis painted in Nathadwara miniatures. Pandits are seen with a circular *tika* on their forehead. This is a peculiar Khandeshi influence. Krishna is depicted as the Blue Lord. It is an exceptional feature of these miniatures that only in one figure do we find Krishna with a *morpankhi mukut*, peacock crown. In the rest of the miniatures, he is shown wearing a crown of a type worn only in Maharashtra. It is also significant that the figure of Krishna shows the input of various artists. In places where it seems as if a skilled artist painted him, his figure looks proportionate and attractive but the work of unskilled artist immediately attracts the attention. The eyebrow has been painted straight. This feature is different from the Rajasthani styles where eyebrows are generally depicted as being more rounded.

In all, these miniatures, the foliage is exceptionally painted. *Kela*, banana; *nariyal*, coconut; *champa*, *parijat*, dense *kela* trees with red petals, *gudhal*, *chameli*, *kewda* and *supari* trees are brilliantly depicted. The *kunja*, or grove, in which Radha sits is painted in the Khandeshi style. The *mandap* is decorated with the white flowers of *chameli* or *sadafuli*. The depiction of flowers trees and animals is based on the Deccan style.

The miniatures of Khandeshi style depict tiny female figures. The eyes are round. They wear *navvari* saris. They wear a *mangal sutra* around their neck and show a *malvat* mark on their foreheads. In some figures, this *malvat* is vertical. The female figures are not very thin and wear a big *chuda* on the right wrist. In all the miniatures where Krishna appears, he

is depicted as *vithoba* or *vitthal*. He is shown painted dark blue, tiny and plump, wearing a long garland of white flowers around his neck. Some important characteristics of the Khandeshi style can be observed in the second category of miniatures. The eyes of Radha and the *duti* are not fully almond-shaped. They are less penetrating. The eyebrows are not circular. In some female figures, we find unusual depictions of the way in which the *sari* is draped. The architecture painted in these miniatures is Khandeshi. In some miniatures, we find the Mewari influence where double-storied houses are painted. The *malvat* on the forehead of the female is a significant Khandeshi feature. This characteristic is not found in any other style. *Ashoka* trees with long leaves and *sadafuli* flowers with five petals are also not features usually found in other styles. The depiction of *parambi* is also peculiar and is absent in the other styles. A particular type of bangle, known as *bangri*; *jhumka*; an oval-shaped gold garland; *odhni* with white pearls; *chinz petty* and *bujatti*—jewellery for the neck—are the main ornaments of this region, painted in these miniatures. *Chourangi*, a particular type of rectangular table used in Maharashtra to keep flowers for worship, has also been shown. Nanda wears a *ghunghri*, which is a particular type of dress, worn by the Abhirs of Khandesh, to protect themselves from the rain. Krishna wears a *shela* or *uparna,* which is a sort of folded shawl, worn by the people in Maharasthra. All miniatures of this illustrated *Geet Govinda* are 10x15 cm except for one in the frame which is 5.5x12.5 cm.

A close observation of these miniatures provides many details which have not been found in any other styles to date. This school is an outcome of the joint efforts made by the Rajasthani, Malwi and Khandeshi artists. This *kalam* has also influenced by the Nagpuri and Deccani styles, especially the toy-like animals and birds.

It is relevant to touch upon the other depictions of this style in Khandesh. The border of Khandesh at present touches the border of Shahada Tehsil, which is a district in the state of Maharasthra. Adjoining this is a district known as Sendhwa. The other end of the border of Khandesh is Asirgarh. Burhanpur, a famous medieval city, comes under Khandesh. Significantly, the execution of miniatures, which took place in Burhanpur, is different from the miniatures executed in Dhule. In Burhanpur, we find the influence of the Nathadwara and Deccan styles, particularly Hyderabad. As Burhanpur is situated on the border of Malwa and Deccan, it can be concluded that an assimilated art style influenced by the Deccani style must have emerged in Burhanpur. This style was also influenced by the Malwa, Mewar and Nathadwara styles. The Hyderabadi influence is also very clear, particularly in the treatment of architecture and atmosphere.

The style that flourished in the area of Burhanpur was different from the style that flourished in the area of Dhule district. In the Samarth Wagdevta Mandir, most of miniatures have been painted in this style. There are 103 miniatures in the illustrated *Geeta Govinda*. In all these miniatures, we find the same treatment of colour and line drawing as we find in the Kanheri *Geet Govinda*. Fourteen stray leaves have also been preserved. *Bad number 629 is Kavyalankar.* It is incomplete, containing nine miniatures. Five miniatures of this illustrated manuscript are centred around Krishna.

The fourteen stray leaves are very important. Ten miniatures of the fourteen belong to *Dashavatar*. In these pictures we find the traditional

treatment. A portrait of Sahuji Maharaj is also significant. The remaining three miniatures are miniatures of Radha and Krishna that belong to the period of Peshwas. These three paintings are very important because they substantiated the advancement of the Kanheri style.

Malwa, which is a region adjoining the state of Maharashtra had a rich artistic tradition. The rulers of Malwa were Maratha and the Maratha influence appeared in the Malwa *kalam*.

In the Scindia Oriental Institute, Ujjain, there are several illustrated manuscripts, executed in early and late 19th century. The miniatures of these illustrated manuscripts are significant as they represent the further advancement and impact of the Kanheri style on contemporary Malwa idiom. One of the important manuscripts is *Bhakti Vijay* which Daggad Munnaji Shinde produced in 1861. This is a religious book composed by Mahipati (1715-1790). In these paintings we find the depiction of Vitthal, in the same way in which Vitthal or Vithoba is depicted in the Kanheri *Geet Govinda*. Likewise, the female figures wear the same ornaments as worn by the female figures of Kanheri *Geet Govinda*. In this manuscript, we find a portrait of Jaideva identical to the one painted by the Kanheri artists.

In the miniatures of Kanheri *Geet Govinda*, we find a dark red twisted line, frequently painted by the artist. Karl Khandalavala discussed this red twisted line in his book *Painting of Bygone Years*. Plate four of this book belongs to Kukubhragini. He was curious to find out how this form travelled from Deccan to Raghogarh. In the miniatures of the Kanheri *Geet Govinda*, as well as in the miniatures preserved in the Scindia Oriental Institute, this line is frequently painted, which is termed as

magenta rock formations by Karl Khandalavala. This was a popular choice of the contemporary artist. Red was a favourite colour of the artist, which was used right from Deccan to Raghogarh. In early Malwa miniatures, we find this type of red line, thin in shape but identical to the line of the forthcoming era. The examination of early Malwa miniatures and Kanheri miniatures reveal the fact that this device originated in Malwa and travelled from Malwa to Deccan as the use of this device in Deccani miniatures occurs later in the period.

The stray leaves, which are preserved in the institute and belong to latter half of 19th century, indicate that the influence of Khandesh travelled towards Malwa. During the reign of Holkars and Pawars the late Malwa style was blended with Khandeshi influence.

This style has been termed 'Kanheri' as it is the fine gift of Khandesh, the region of Kanha. Kanheri means an incarnation of Radha and Krishna, where we see the complete annihilation of both.

Geet Govinda is a poem devoted to Radha and Krishna and the word 'Kanheri' represents the both in one. This particular school should be considered an independent school as it has its own original characteristics. This style is a unique legacy of the Indian artistic tradition. ∎

1 Sulabha Vishwa Kosh.
2 For reference and the theory of the origin of Abhirs see the article by S.K. Bhattacharya. "Iconography of Krishna", in *Rooplekha*, Vol.XXX, No. 1&2 (July 1959).
3 For more details, refer to *Bhartiya Sanskrati Kosh* (Vol.VI), edited by Mahadev Shastri, *Valmiki Ramayana—Yuddhakanda* (The War), Canto 22 and *Padma*, *Vaman*, *Brahmanda* and *Markendeya Purana*. The inscriptions found in Nasik and Ajanta also reveal the fact that Abhirs dominated this area in the early centuries.

Album Section

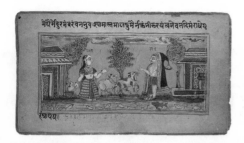

Plate 1, Opening verse, 1st Canto

The sky is surrounded by dark clouds.
The forestlands are darkened by *tamal* trees.
Krishna fears these in the night, hence, O Radha,
accompany Krishna and take him to his home.

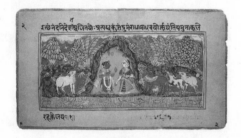

Plate 2, Opening verse, 1st Canto

Ordered by Nanda,
Radha and Krishna are going through
The thickets under *tamal* trees
And on every step they enjoy
Love-plays in loneliness.
On the Yamuna river's bank
These secret love plays may be victorious.

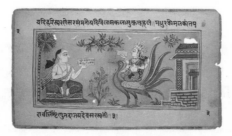

Plate 3, 1st Canto, Couplet 4

If your heart wants to remember Hari,
If you are curious about the arts of his seduction,
you should listen to the sweet, soft and lovable
lyrical poems of Jaideva.

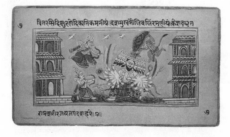

Plate 4, 1st Canto, Couplet 11

In the battle, you have spread in all directions the
sacrifice of Ravana's ten heads; this joyful deed
was much liked by the gods of directions.
O Kesava, you have performed this deed while you
were the incarnation of Ram.
O lord of the world, O Hari, may you be victorious.
O lord of the world, O Hari, may you be victorious.

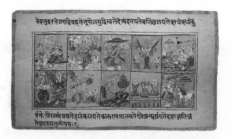

Plate 5, 1st Canto, Couplet 16

By incarnating as fish, you have upholded the
Vedas
By incarnating as tortoise, you have given support
to the earth
By incarnating as boar, you have raised the world
By incarnating as partly man and partly lion, you
have torn the demon Hiranyakasipu
By incarnating as Vaman, you have cheated
King Bali
By incarnating as Parasuram, you have destroyed
the warrior class
By incarnating as Ram, you have conquered
Ravana
By incarnating as Haldhara, you have killed
numerous demons
By incarnating as Buddha, you have spread
compassion
By incarnating as Kalki, you have routed the
barbarians
O Krishna, we pay homage to all your ten
incarnate forms.

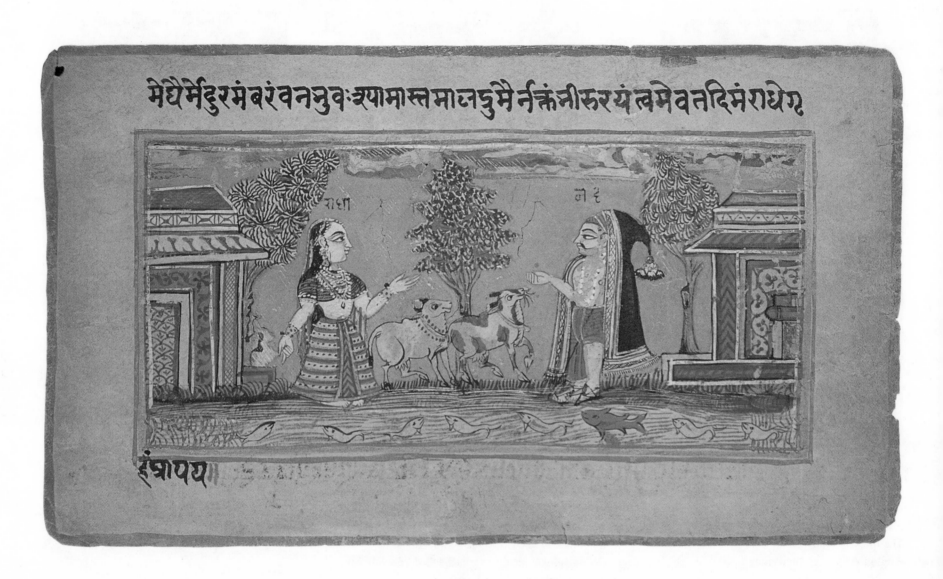

Plate 1 **Nanda directing Radha**

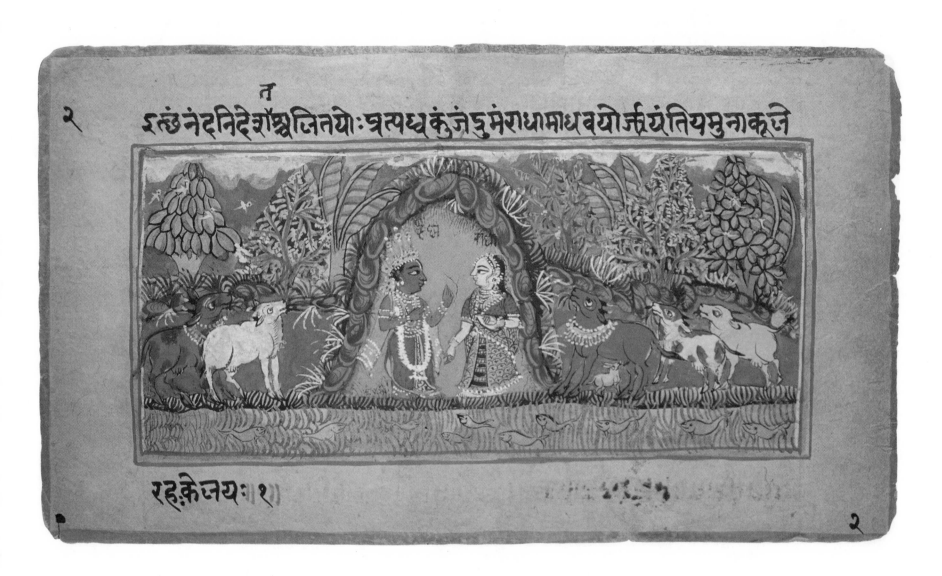

Plate 2 **Radha and Krishna in the grove**

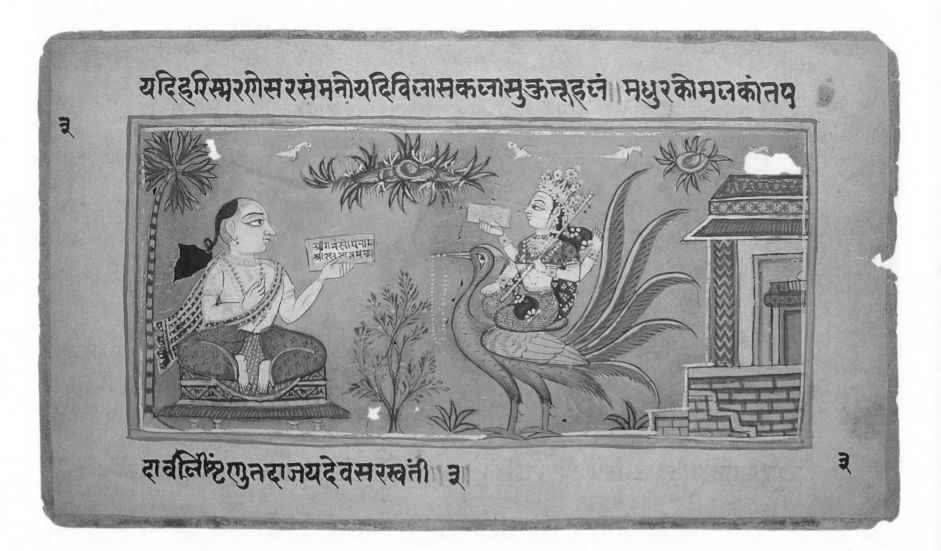

Plate 3 **Jaideva and the goddess Saraswati**

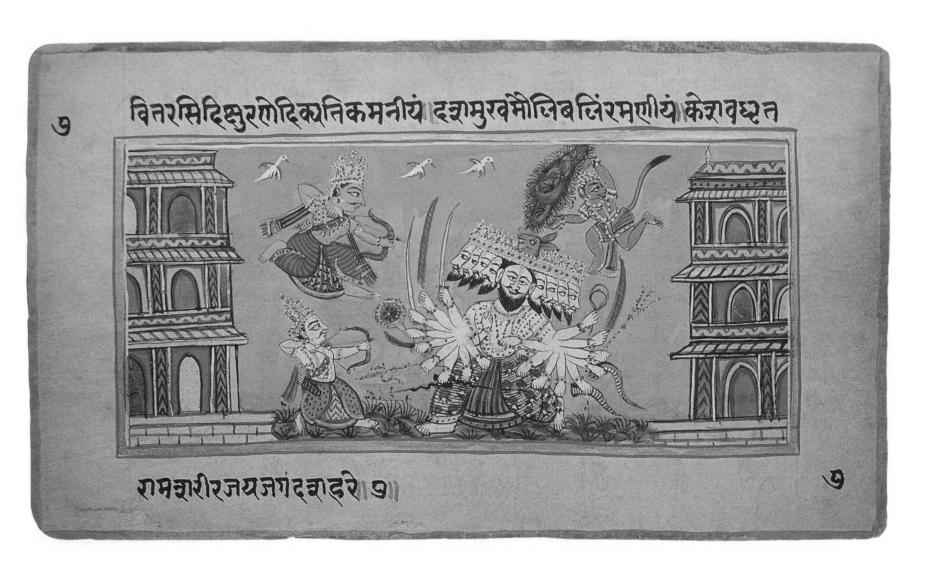

Plate 4 **Rama killing Ravana**

वेदानुद्धरने जगन्निवहते नूगेजमुद्धित्रने दैत्यंदारयतेबलिंछलयते त्रिंत्रयंकु

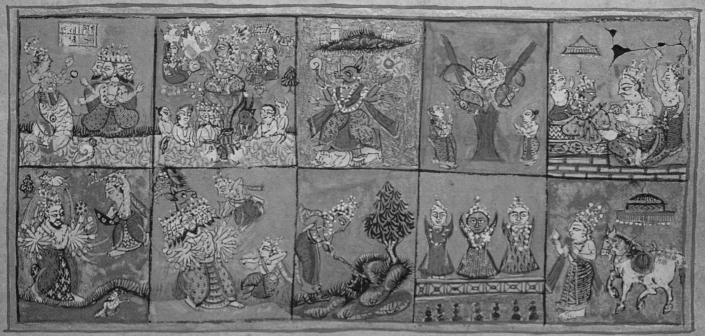

वने यौजस्यंजयतेदलंकजयते कारुए गमातन्वते लेछान्मूर्छयते दशाकृतित्रि
ते कृष्णायतुभ्यंनमः१

Plate 5 **The ten incarnations of Krishna**

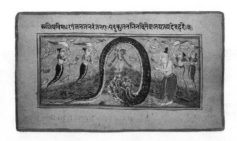

Plate 6, 1st Canto, Couplet 19

You have defeated the venomous serpent Kaliya,
You always give happiness to your devotees,
You are like the sun and give blooms to your
Yadu kinsmen;
O Hari, may you be victorious, again and again.

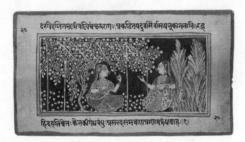

Plate 7, 1st Canto, Couplet 35

The wind carries fine pollen
Shaken loose from half-blossomed jasmine
And perfumes the forests.
Spreading the cactus fragrance,
The wind burns the heart,
Excites the passion of love,
The essence of the god Kama
Who holds
An odd number of arrows.

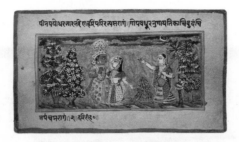

Plate 8, 1st Canto, Couplet 39

A cowherd-girl with heavy breasts
Lovingly embraces Krishna
In the fifth raga to attract and please him.
In such an atmosphere, Hari revels
As the crowd of charming girls revel in seducing
him to play.

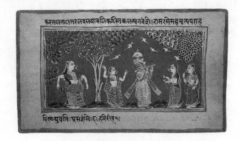

Plate 9, 1st Canto, Couplet 43

Krishna plays on the flute a low note
A cowherd-girl comes forward, and
Dances in the rite of love
Clapping her hands and ringing bangles.
Hari revels here as the crowd of charming girls
Revel in seducing him to play.

Plate 10, 2nd Canto, Couplet 1

When Hari roamed in the forest
For making love
Radha thought she had lost her hold
On him and envy drove her away.
In the thickets of wild vines she went
to the sound of buzzing black bees.
Depressed, she
Told her friend in loneliness not to tell the others.

Plate 11, 2nd Canto, Couplet 2

It seems as if the nectar of his lips takes the shape
of the sweet notes of his flute
While Krishna plays on alluringly.
His restless eyes glance, his head sways and
Earrings dance over his cheeks.
(My heart recalls Hari in his love dance
Seductively playing, laughing and mocking me.)

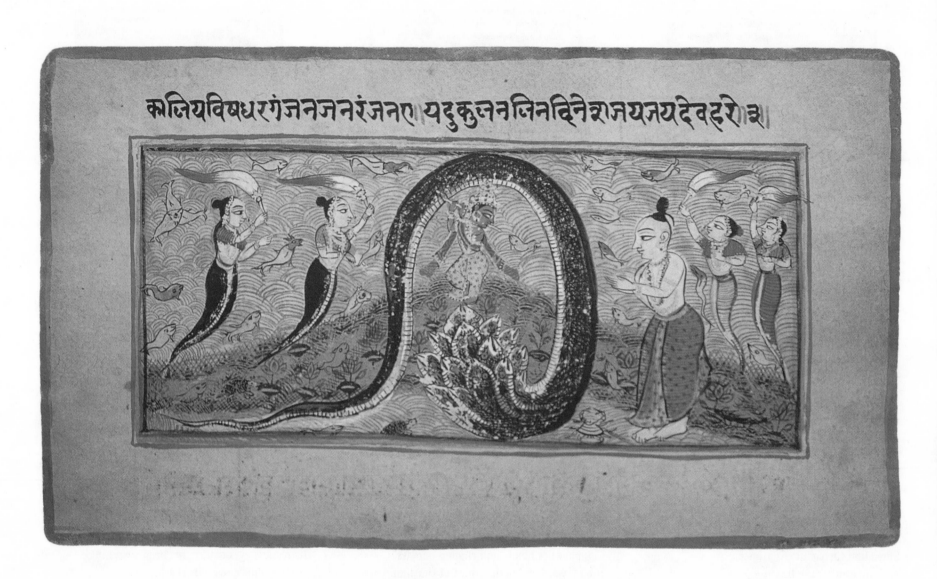

कलियविषधरगंजनजनरंजन यदुकुलनलिनदिनेराजयजयदेवहरे ।

Plate 6 **Defeat of the serpent Kaliya**

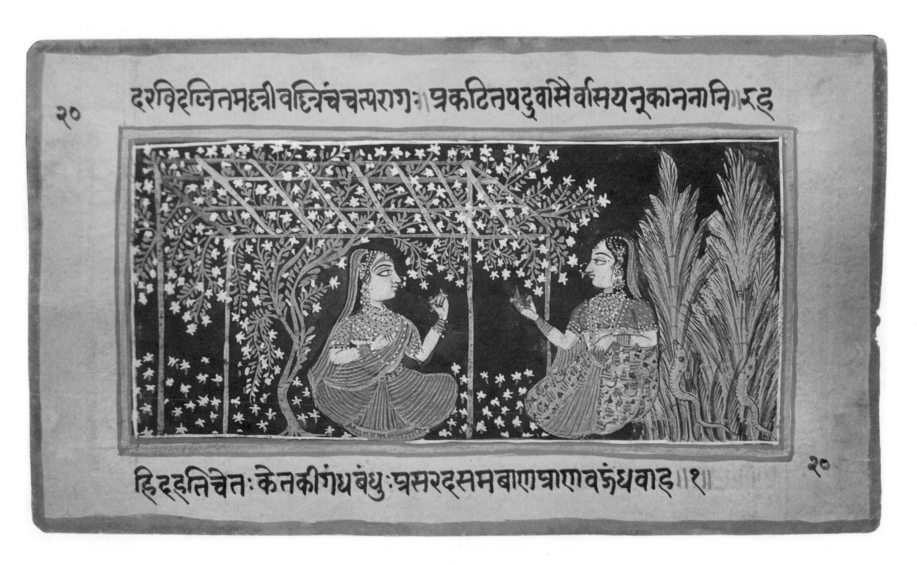

Plate 7 **The wind burns the heart**

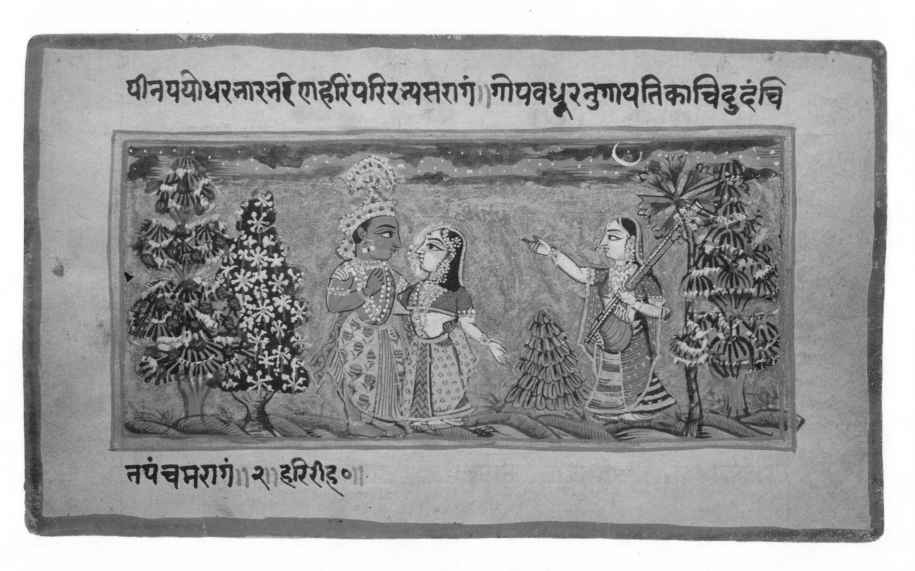

Plate 8 **Krishna** and a *gopi*

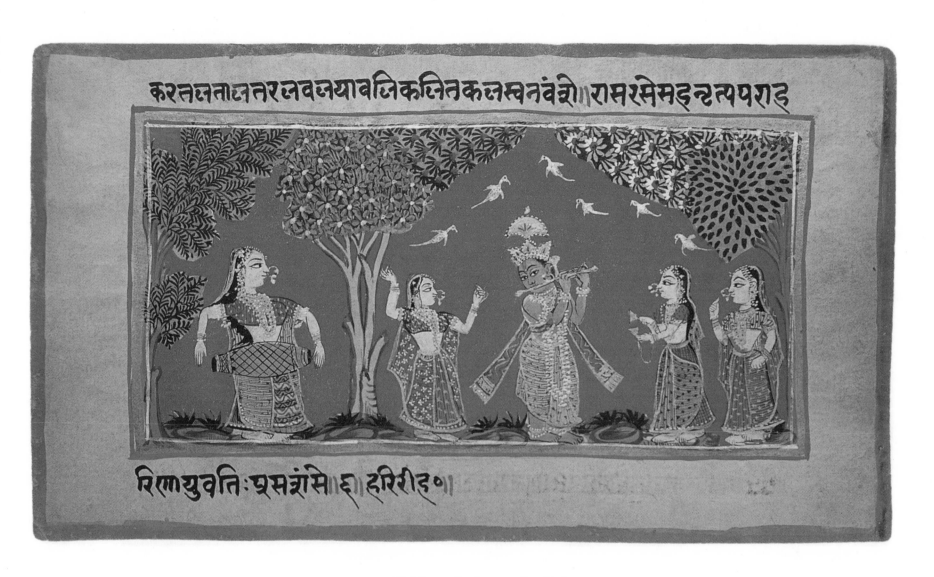

Plate 9 **Krishna playing on the flute**

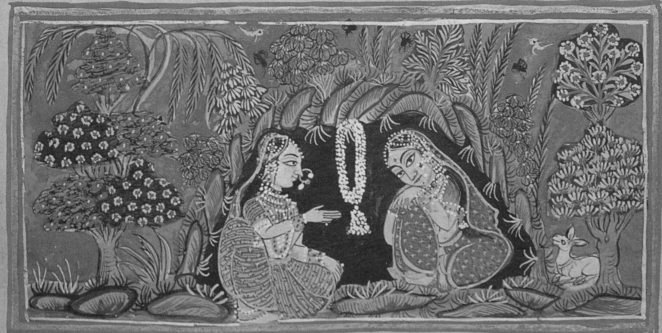

विहरति वने राधा साधारणप्रणये हरौ विगलितनिजोत्कर्षाद् ईर्ष्यावशेन गतान्यतः

कचिदपि विलताकुंजे गुंजन्मधुव्रतमंजुली मुखरशिखरे लीनादीनाप्युवाचरहः मखि ॥२॥ च

Plate 10 **Radha disheartened**

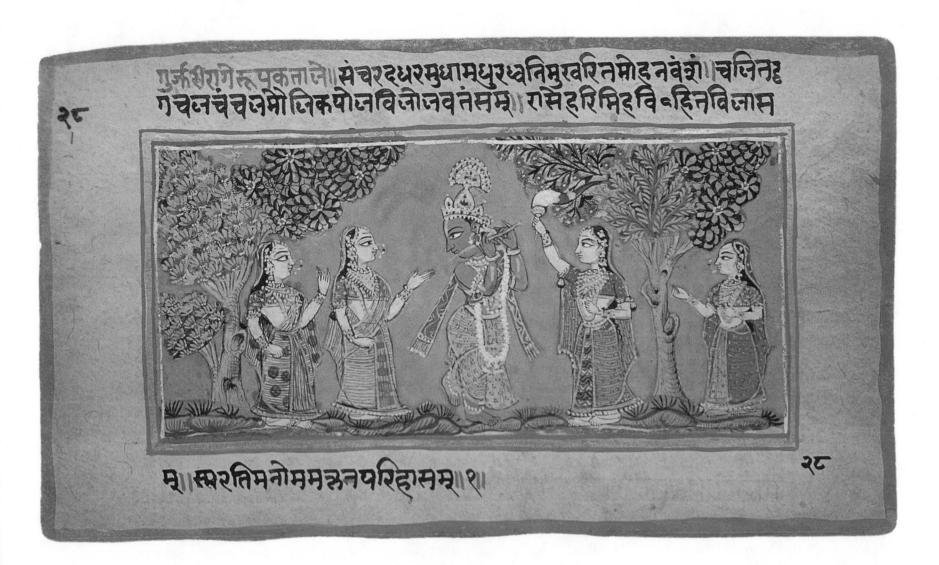

Plate 11 **Krishna and the** *gopis*

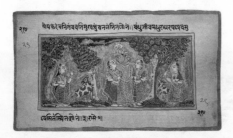

Plate 12, 2nd Canto, Couplet 4

Kissing the mouths of fleshy-hipped cowherd-girls
Does not end his lust.
Charming smiles flash from his sweet lips,
Which are like the buds of a *bandhuk* flower.
(My heart recalls Hari in his lovedance.
Seductively playing, laughing and mocking me.)

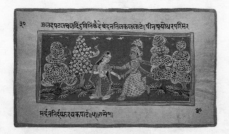

Plate 13, 2nd Canto, Couplet 6

Sandalwood paste marks Krishna's dark forehead.
The moon shines out from a mass of clouds.
His cruel heart is a hard door,
He bruises the round breasts of cowherd-girls.
(My heart recalls Hari in his love dance
Seductively playing, laughing and mocking me.)

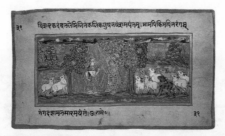

Plate 14, 2nd Canto, Couplet 6

Meeting me under a huge *kadamba* tree,
Giving end to my fear of dark times and glancing at me
With his passionate eyes, giving delight to my heart.
(My heart recalls Hari in his love dance
Seductively playing, laughing and mocking me.)

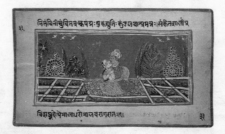

Plate 15, (No mention in the other manuscripts)

Krishna, intoxicated in love
Kissing a fleshy-hipped young cowherd-girl.
His body gleams like a blue parrot.
Krishna, the king of *Malava Raga*
Wore earrings and a garland of flowers
Indicating that he would enter
The thickets in the evening.

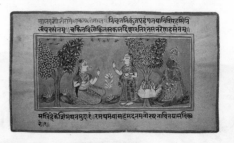

Plate 16, 2nd Canto, Couplet 11

I went to a lonely forest hut
Where he secretly lies at night.
I searched for him in all the directions
As he laughed passionately.
O friend, bring the demon Kesi's sublime tormentor
To revel with me, who is going mad with passion
Before his fickle love changes.

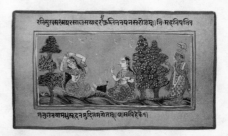

Plate 17, 2nd Canto, Couplet 17

I am getting lethargic with
Passion's joyful time
My body falls like a limp vine.
The demon Madhu's foe,
Whose lotus eyes are barely open
And who, delights me with love.
O friend, bring the demon Kesi's sublime tormentor
To revel with me, who is going mad with passion
Before his fickle love changes.

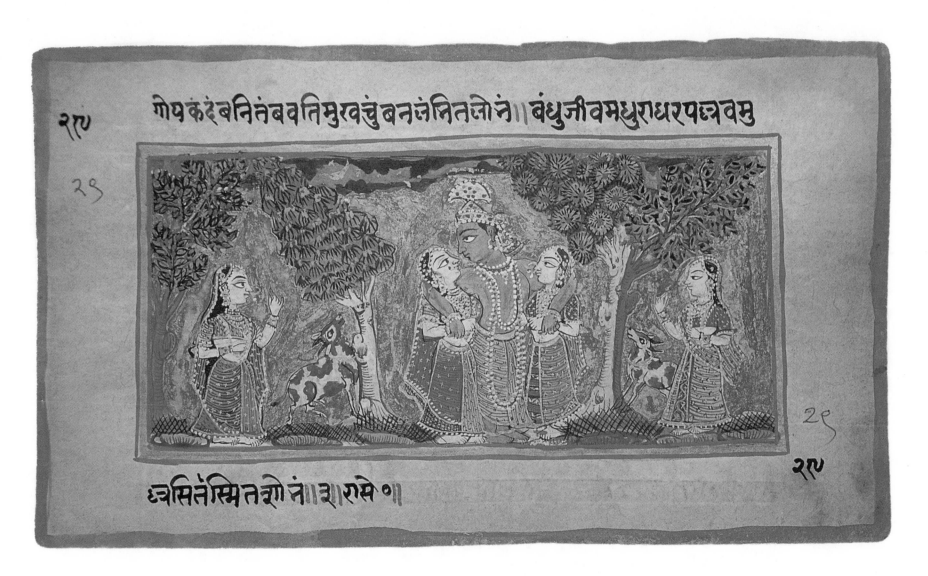

Plate 12 **The love game of Krishna**

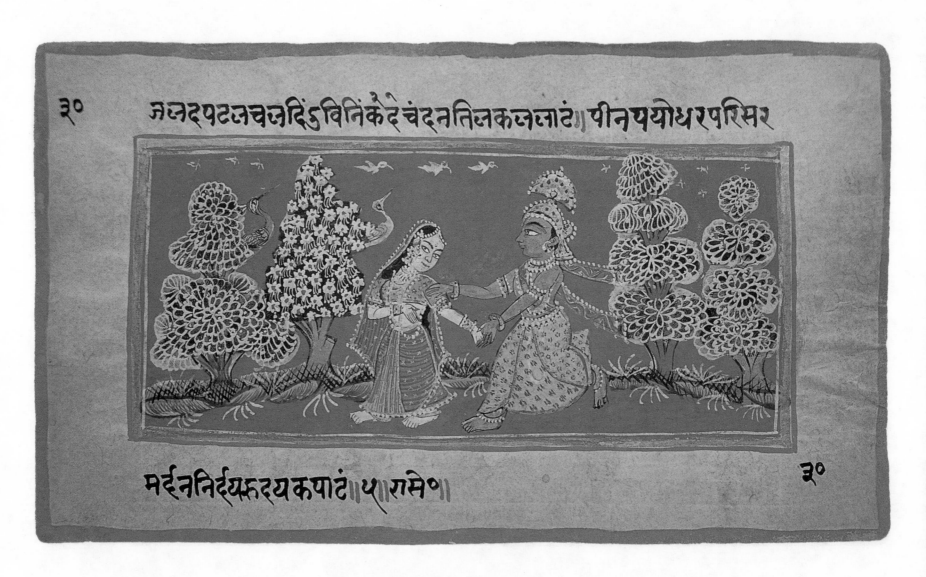

Plate 13 **Krishna dancing**

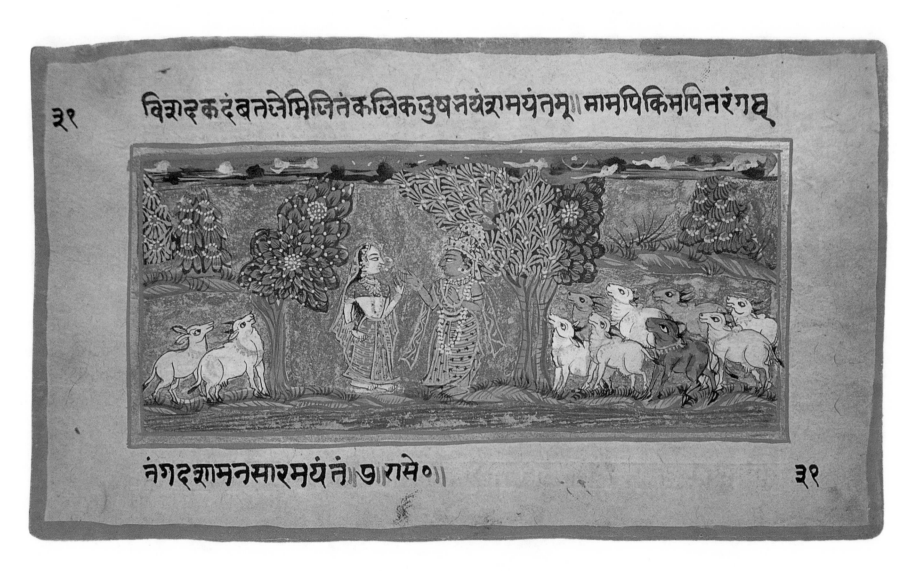

Plate 14 **Krishna under the *kadamba* tree**

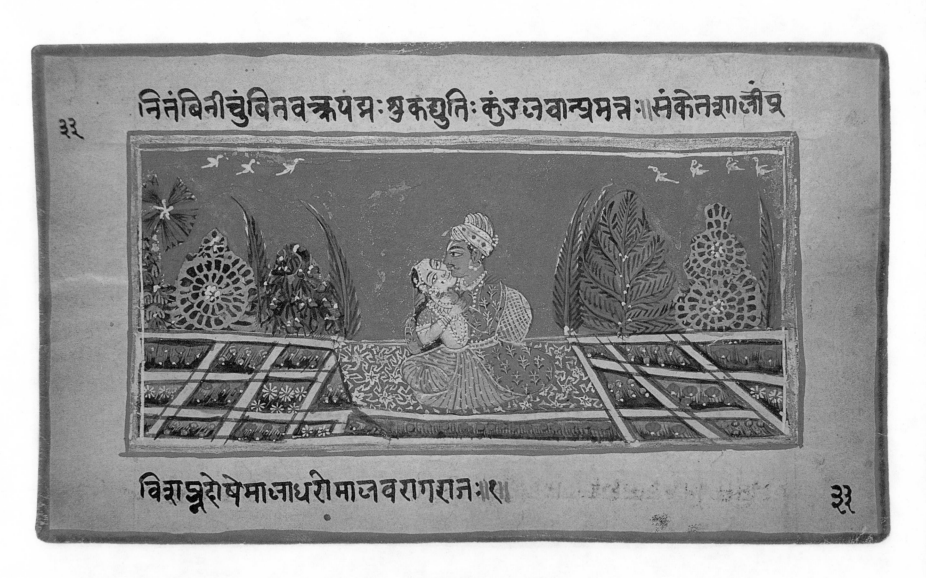

निनंबिनीचुंबिनवक्रयत्रः शुकद्युतिः कुंजलवात्रमत्रः संकेतशालीत्र

विशङ्करोषेमाजाधरौमाजवरागराजः॥३०॥

Plate 15 **The intoxication of love**

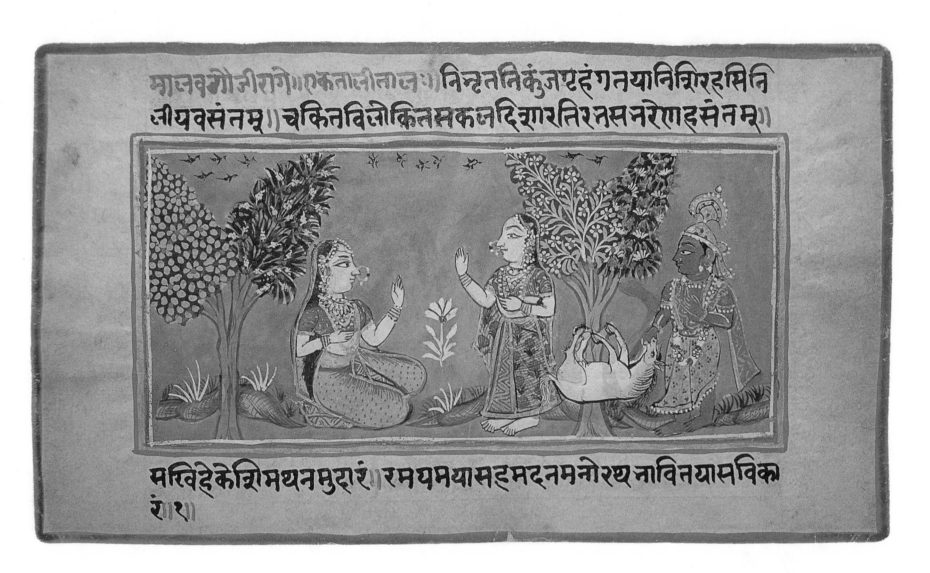

Plate 16 **Radha and her companion**

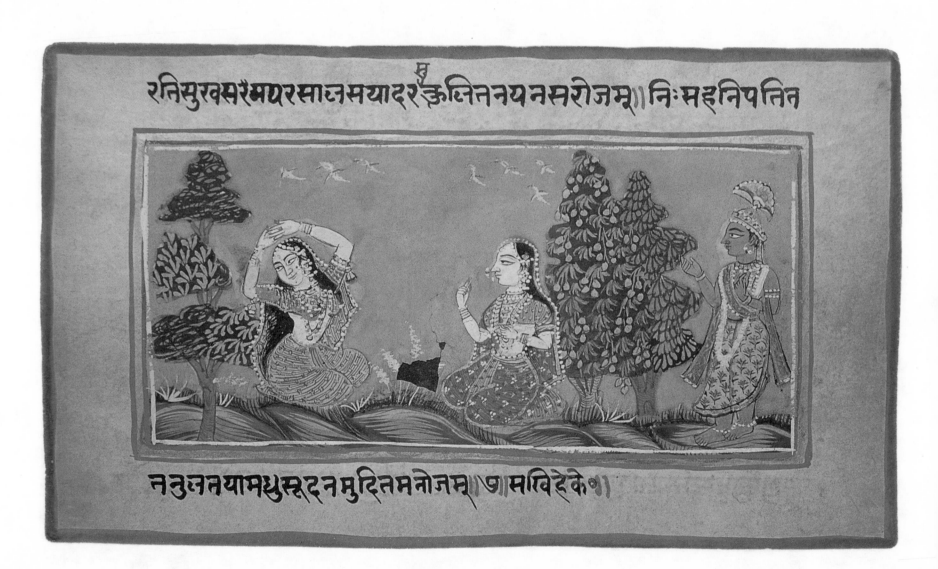

Plate 17 **Radha weary**

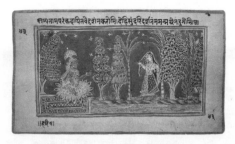

Plate 18, 3rd Canto, Couplet 9

Forgive me now, I won't do this to you again.
O damsel, grace me by making your appearance
I am burning with the passion of love.
Damn me! Her self respect is hurt
My wanton ways have left her in anger.

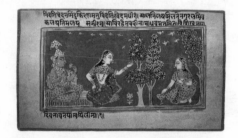

Plate 19, 4th Canto, Couplet 2

She does not like the cool sandalwood balm
Because it seems hot to her,
She feels moonbeams piercing her body.
She is impatient and sunk in weariness
She feels the winds full of venom
From the nests of deadly snakes.
She is dejected by your desertion.
O Madhava! she clings to you in fantasy
Fearing Kama's arrows.

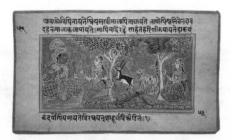

Plate 20, 4th Canto, Couplet 10

Her house becomes a jungle which
A band of her loving friends seems to share.
Her sighs increase her pain to flames
That rage like forest fire.
Suffering Krishna's desertion
She takes the form of a doe
Kama takes the form of tiger,
The god of death hunting his prey.

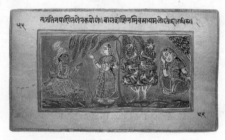

Plate 21, 4th Canto, Couplet 16

She keeps her cheek on her palm
And she never moves
Thus, her cheek is wan
As a crescent moon in the evening
O Krishna, Radha suffers in your desertion.

Plate 22, 5th Canto, Couplet 4

When the swarm of black bees
Makes the buzzing sound of love
Krishna covers his ears
Your desertion affects his heart
Inflicting pain, night after night.

Plate 23, 6th Canto, Couplet 2

In her seclusion
She looks for you in every direction
She imagines you drinking the honey
Of her lips.
O Lord Hari,
Radha suffers in her retreat.

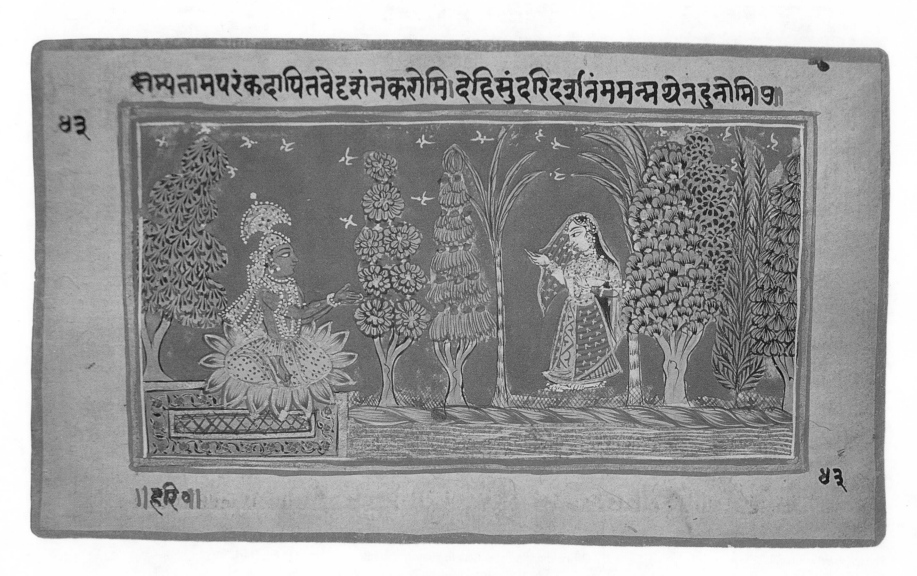

Plate 18 **Krishna asking for forgiveness**

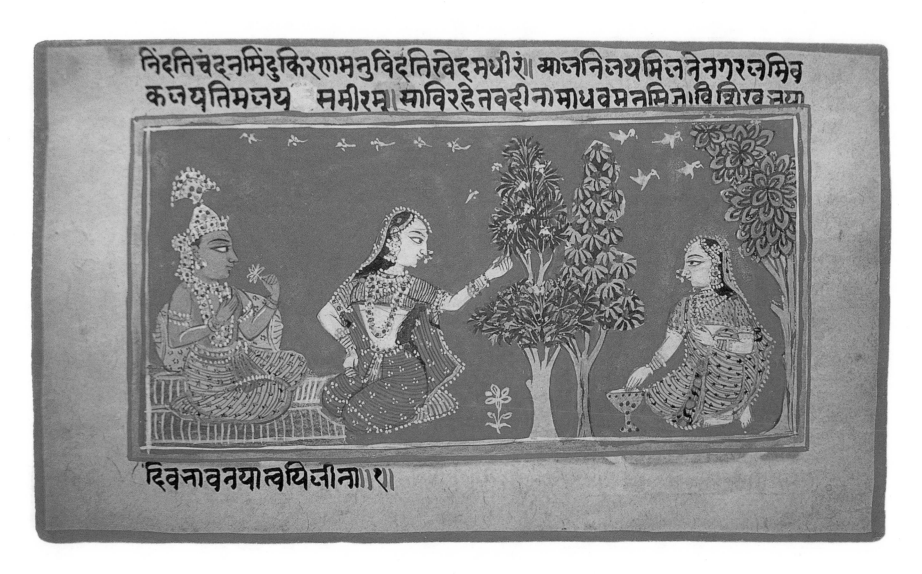

Plate 19 **Radha dislikes cool sandalwood balm**

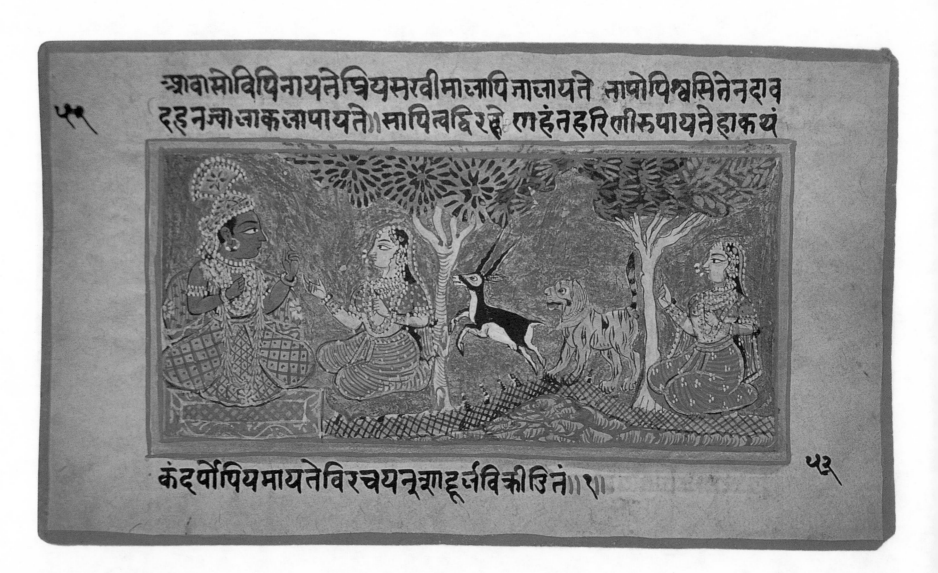

Plate 20 **Kama disguised as a tiger**

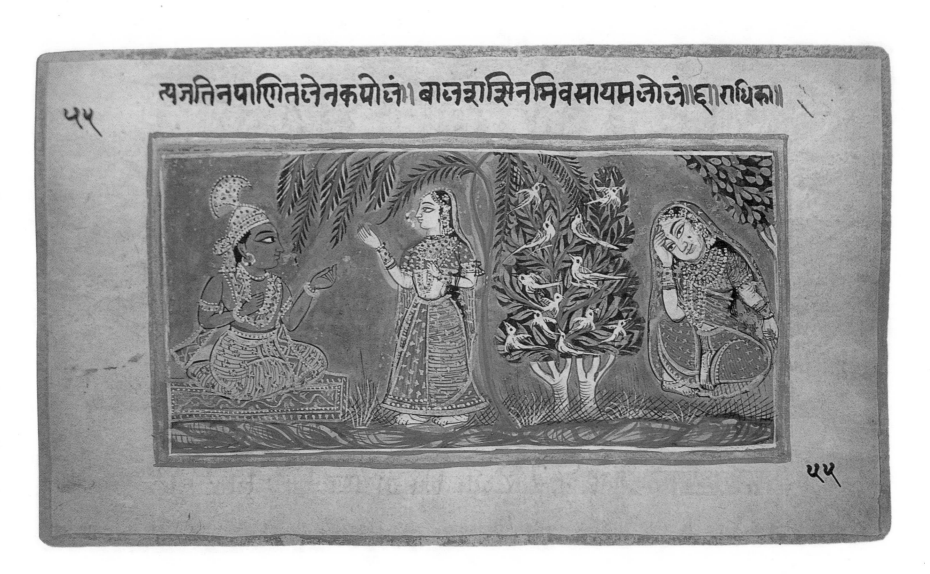

 Plate 21 **Radha desolate**

ध्वनितिमधुपसमूहैश्रवणाश्रवणमपिदधानि मनसिचलितविरहेनिशि

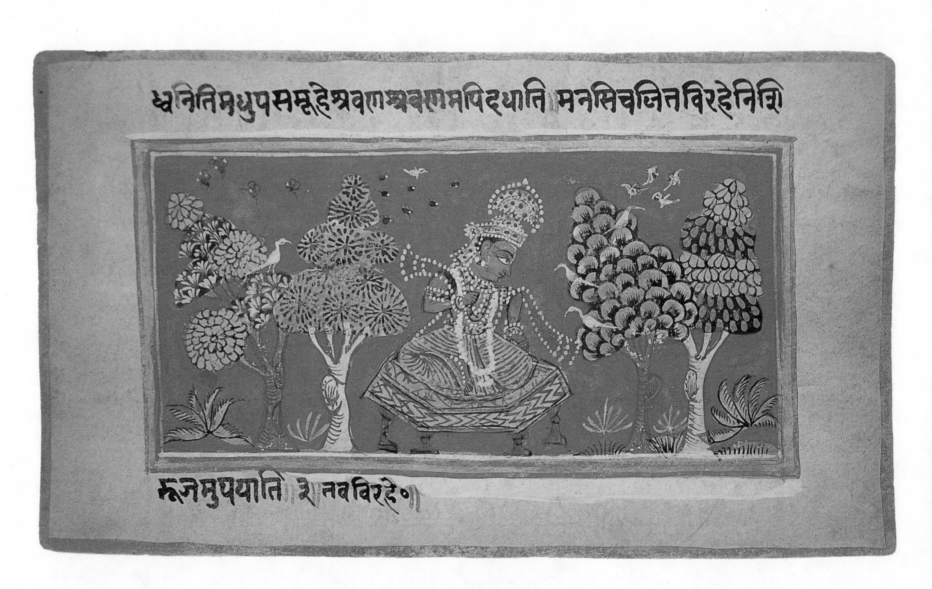

ब्रजमुपयाति ३ नवविरहे॥

Plate 22 **Krishna desolate**

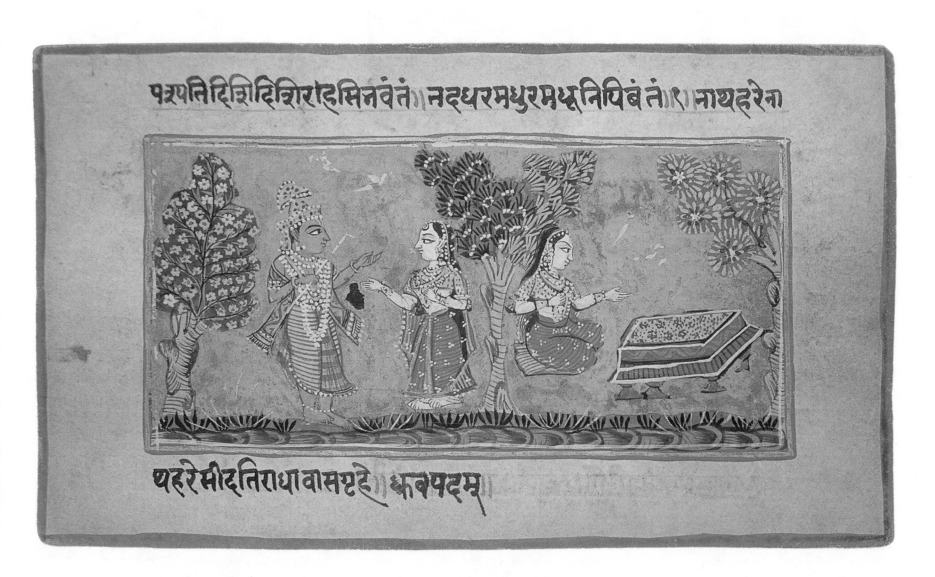

Plate 23 **The *sakhi* describing Radha's condition**

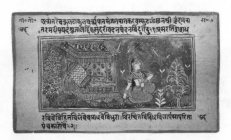

Plate 24, 7th Canto, Couplet 1

In the meantime the moon rose in the sky
The cratered stains on it seemed to flaunt its guilt
It betrayed the secret paths of
Adulterous women.
The moon lightened the depths of brindavan
With its moonbeam nets.
It looked as if the west is a
Dainty dame
Who has put a round mark of sandalwood paste
On her forehead!

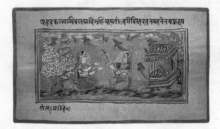

Plate 25, 7th Canto, Couplet 7

Every bangle and ornament pains me
Carrying the fire of Hari's desertion
Whom can I find refuge in here!
My friend's words have deceived me.

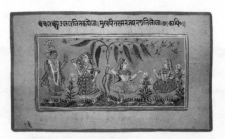

Plate 26, 7th Canto, Couplet 16

Her quivering earrings graze her cheeks
And her belt tinkles
While her hips roll as she walks
A young voluptous girl
Revelling with the enemy of the demon Madhu.

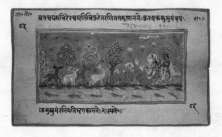

Plate 27, 7th Canto, Couplet 23

Krishna laying an amaranth blossom
In the lock of hair of a fickle-hearted young
woman. It shines like a shimmer of lightning
In the clouds of her hair.
Her lock of hair seems like a forest
Where Kama roams in the form of deer.

Plate 28, 8th Canto, Couplet 7

O dark Krishna, your heart is certainly a baser black
Than your skin.
How can you deceive a faithful creature
Tortured by the arrows of Kama
Damn you, Madhava! Go, Keshava leave me!
Don't plead your lies with me!
Go after her, Krishna!
She will ease your despair.

Plate 29, 8th Canto, Couplet 10

I see the outwardly exposed red stains
Of her lac-painted feet.
Lovingly left on your chest with
Increasing passion.
O cheat! the image of you
Breaking our love, now appears.
This causes me more shame than sorrow to me.

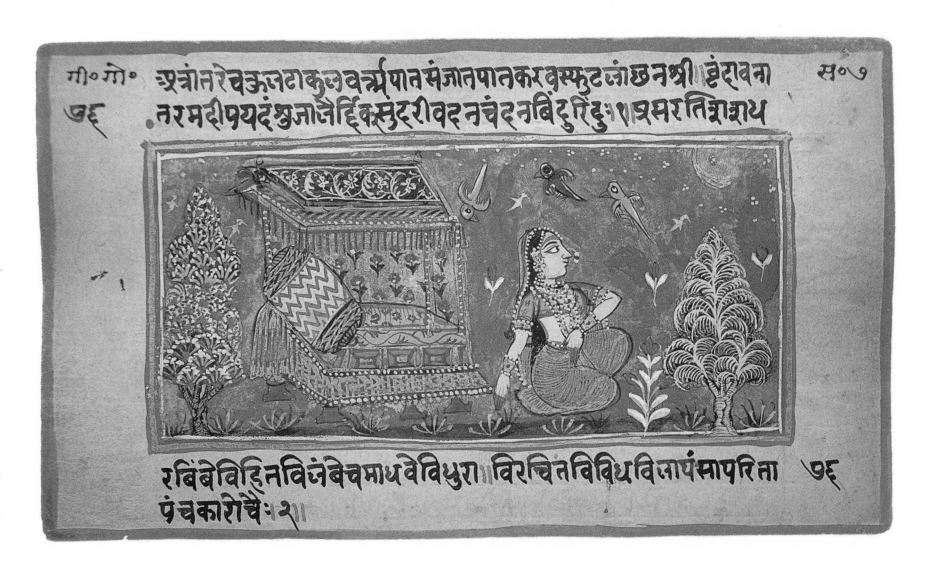

Plate 24 The moon rises in the sky

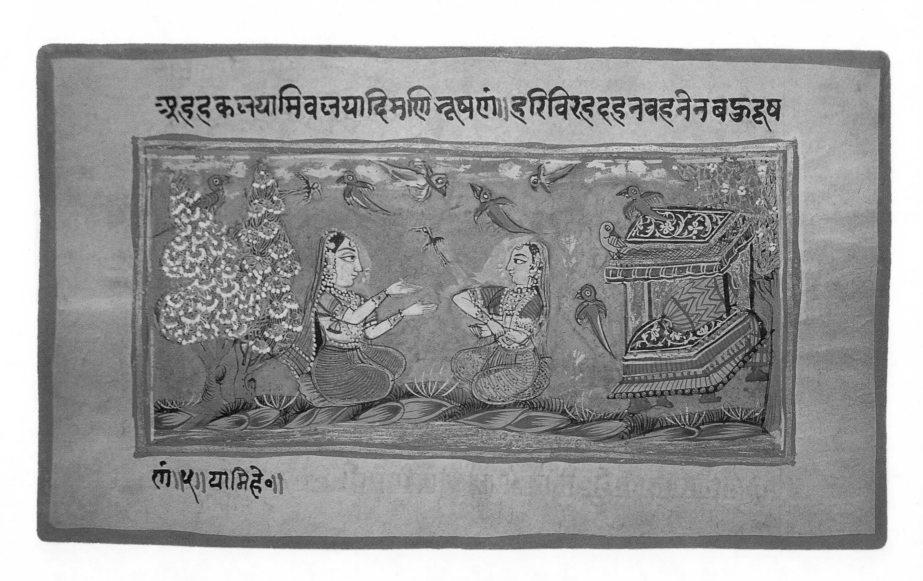

Plate 25 **Radha and her** *sakhi*

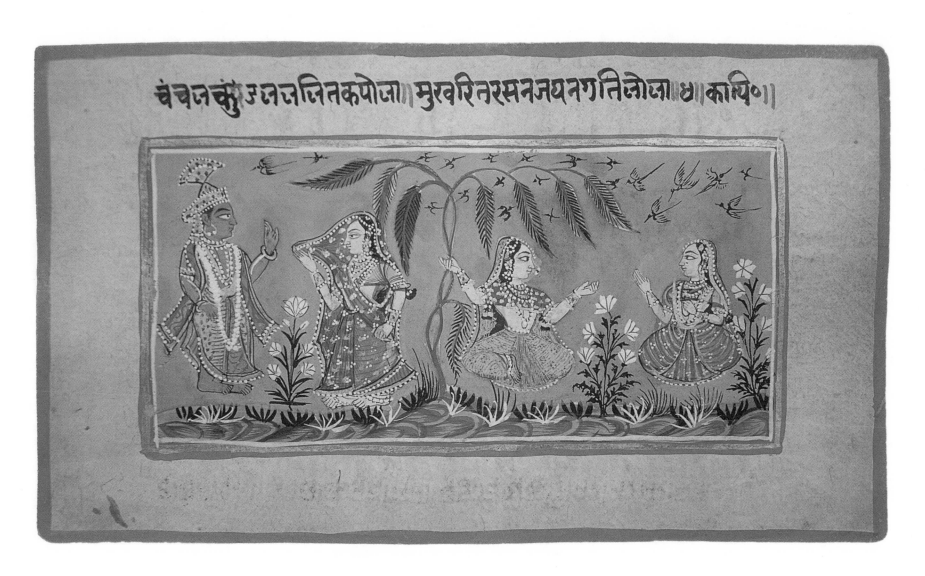

Plate 26 **Radhas imagines Krishna**

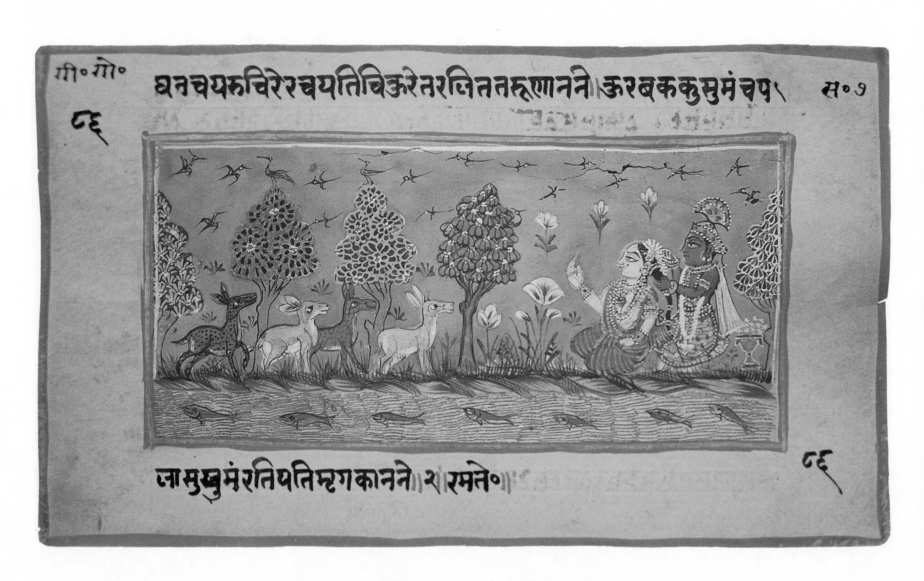

Plate 27 **Krishna laying** *amaranth* **blossoms**

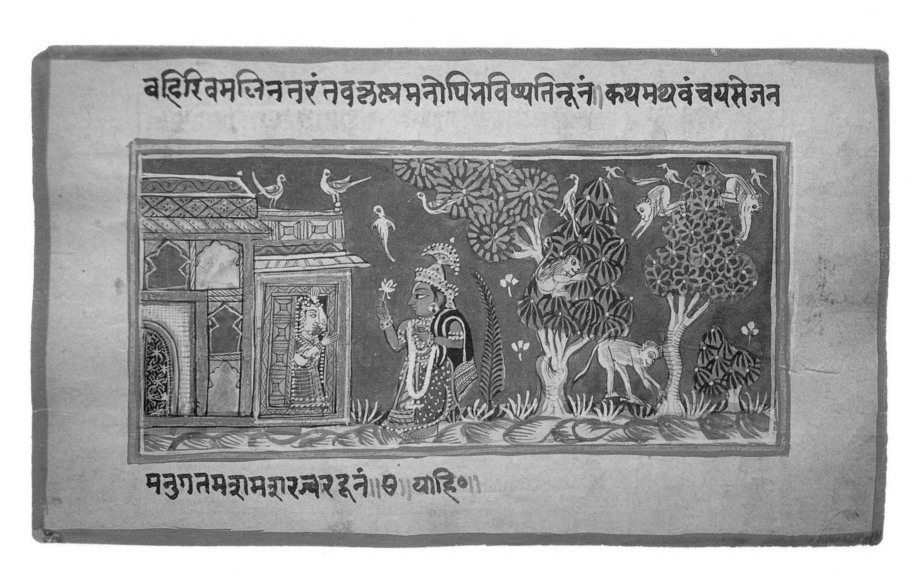

बहिरिवमलिन तरं नवल्लम मनोपिनविष्यतिनूनं कथमथवंचयसेजन

मनुगतमश्रामश्राखरदूनं ॥ ७ ॥ यहि०

Plate 28 **Radha rebuking Krishna**

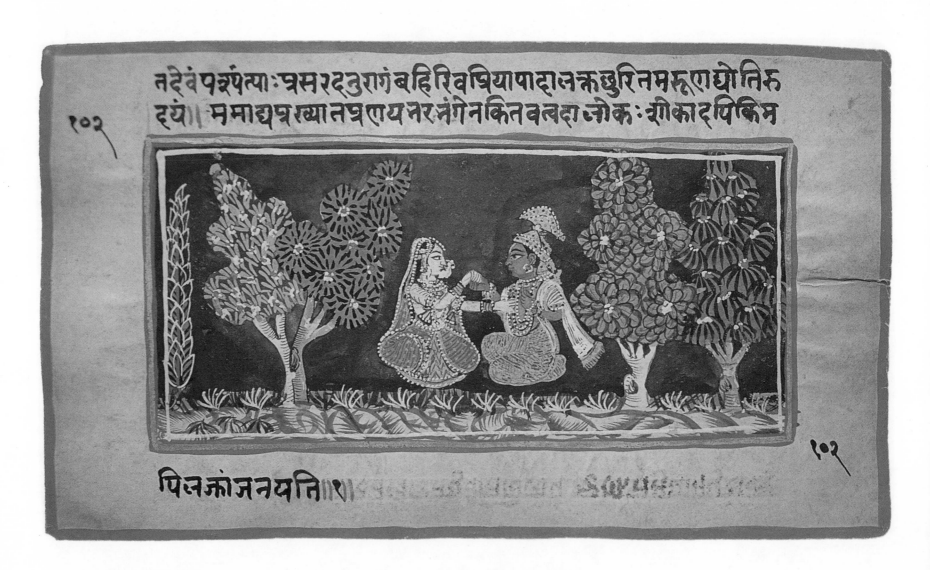

Plate 29 **Krishna** with a *gopi*

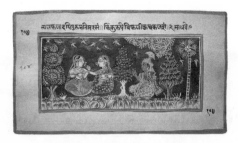

Plate 30, 9th Canto, Couplet 3

Your swollen breasts are bigger and riper
Than palm fruits
Why do you waste the rich flavour of your breasts?
They are like two ritual vessels
O sullen Radha, don't take your wounded pride out
on Madhava. He is filled with pride too!

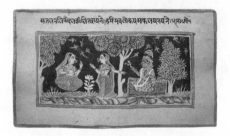

Plate 31, 9th Canto, Couplet 6

Look! Hari on this cool couch
Of petals of lotuses
Blesses your eyes with this fruit.

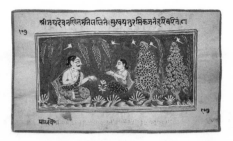

Plate 32, 9th Canto, Couplet 9

May Jaideva's lilting song
Please passionate men who hear Hari's story
O sullen Radha, don't take your wounded pride out
on Madhava. He is filled with pride too!

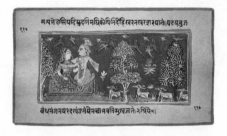

Plate 33, 10th Canto, Couplet 3

You have lovely teeth, O Radha.
If you are really enraged at me
Wound me with your sharp nails.
Bite me in your arms! Bite me with your teeth!
Or do whatever excites your pleasure.
O dear Radha, abandon your baseless pride.
Love's fire burns my heart
Allow me to drink the wine of your lotus mouth.

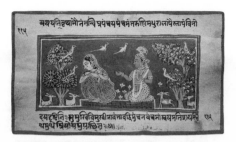

Plate 34, 10th Canto, Couplet 12

O frail Radha, your useless silence tortures me.
Sing sweet lyrics in the mode of love.
O tender young Radha, destroy the fever of my love
With your sweet talk and lovely eyes.
O beautiful Radha, leave your indifference
And don't leave me.
I am deeply devoted to you and am your lover
Present here in person.

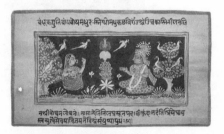

Plate 35, 10th Canto, Couplet 13

O Radha, your moist lips shine
Like a crimson flower.
O fierce Radha, your eyes glow
Like a blue lotus flower.
O beloved! Your teeth shine like jasmine.
Kama armed with arrows made of flowers
Conquers the world
By worshipping your face.

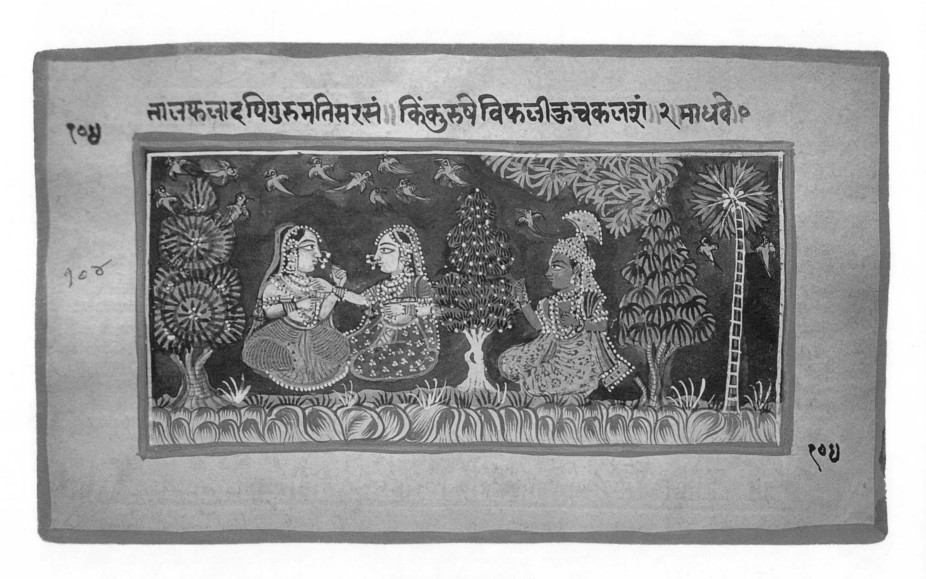

Plate 30 **Radha is angry**

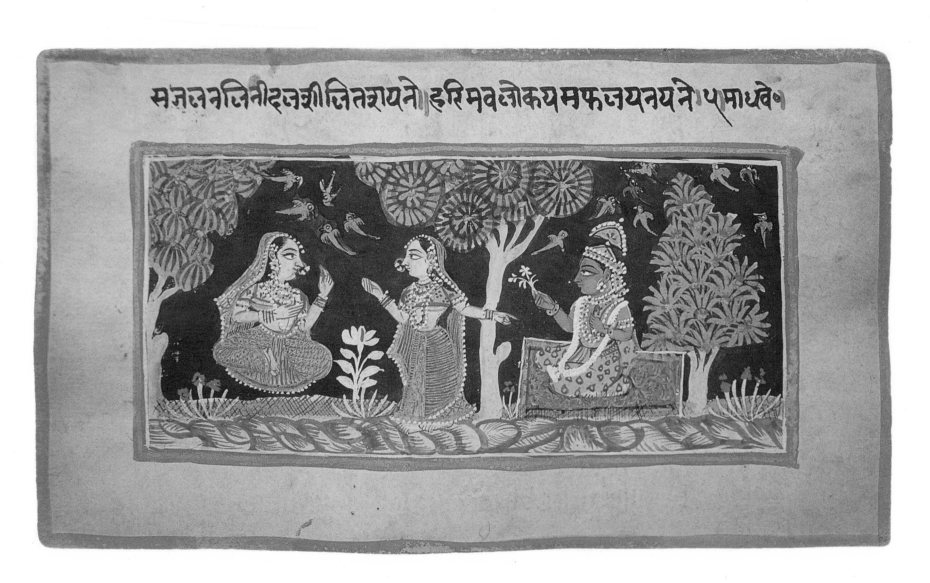

मजननजिनीदरजश्रीजितरायने हरिमवलोकयमफजयनयने ध माधवेन

Plate 31 **The** *sakhi* **addressing Radha**

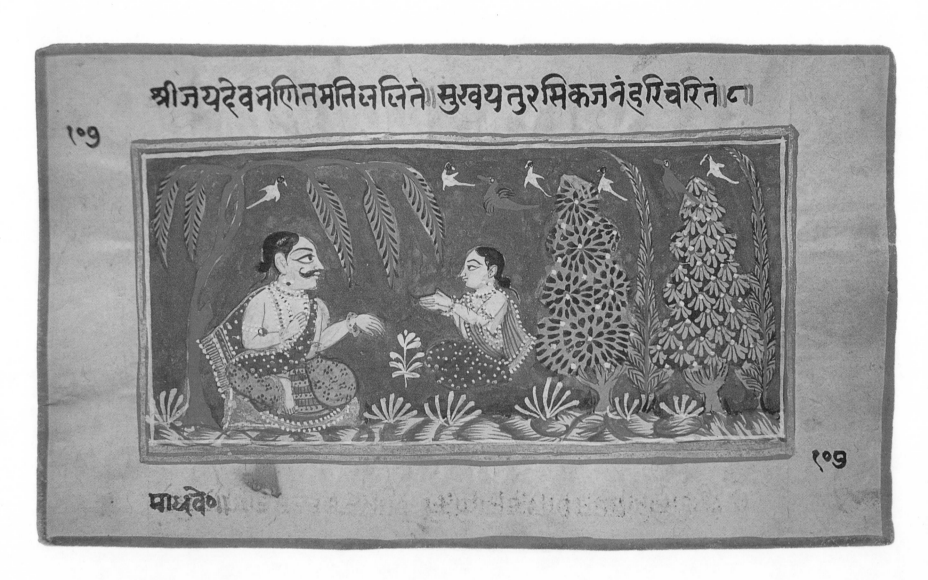

Plate 32 **Jaideva**

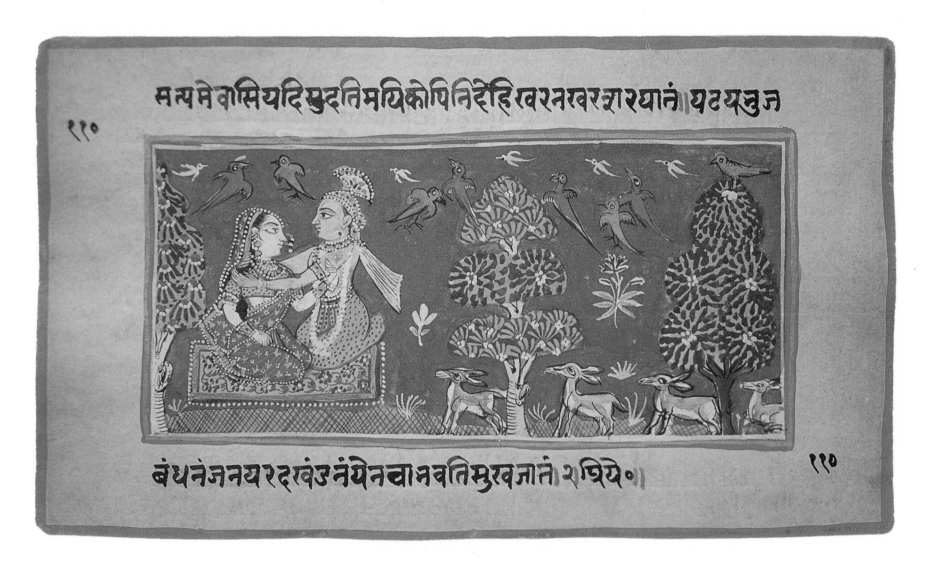

Plate 33 **Krishna appeasing Radha**

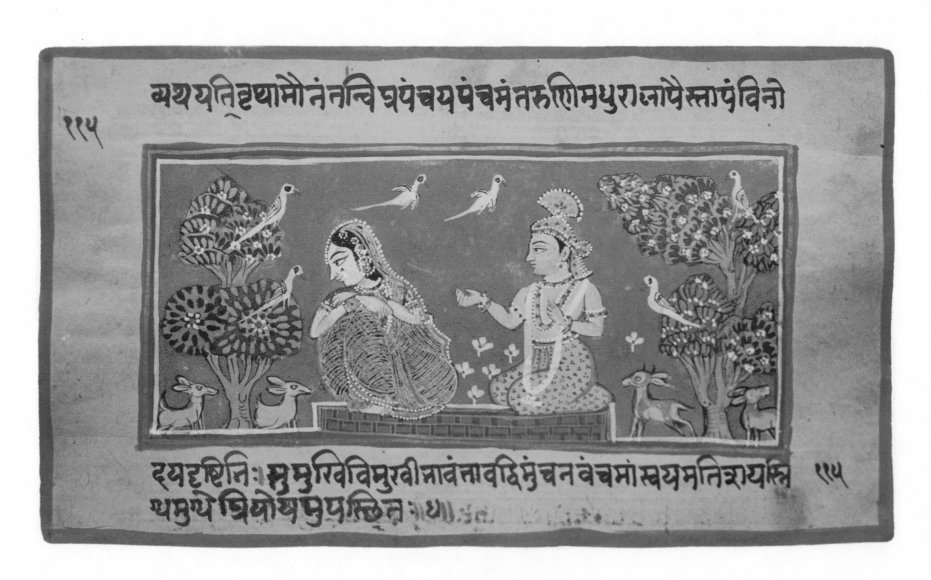

Plate 34 *Manini Radha*

बंधूकद्युति बांधवोयमधुरःस्निग्धोमधुकछविर्गऊप्रेउ चिकास्तिनीलनलि

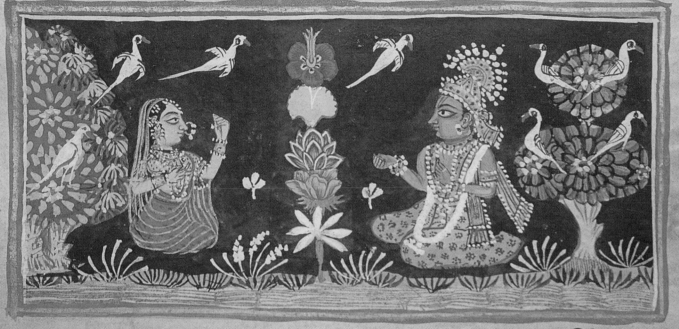

नश्रीमोचनलोचनं नामान्येतिनिःप्रसून पदा बीकुंदा नरंति प्रियेष्ठा
स्तन्मुर्वे सेवया विजयने विश्वं संयुष्या युधःꣳ५

Plate 35 **Krishna flattering Radha**

Plate 36, 11th Canto, Couplet 6

Mighty waves of love throb in you.
They suggest that you wish Krishna's embrace.
Ask your breasts like ritual vessels
Which wear a chain of pearls
Like drops of fresh water.
O fool Radha! He, the tormentor of Madhu,
Is faithful to you,
Follow him.

Plate 38, 11th Canto, Couplet 33

When Radha reached Krishna's bed
Her friend went away, hiding a smile.
Pretending as if her skin was burning
Radha began to look
At the handsome face of her lover
As if she was piercing it.
In doing so, doe-eyed Radha let go of the shyness,
With which she was always filled.

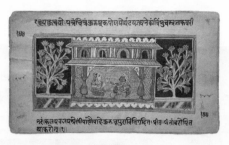

Plate 40, 12th Canto, Couplet 20

Paint a leaf on my breasts.
Make a painting on my cheeks
Lay a girdle on my hips
Twine my lock of hair with a garland of flowers.
Put rows of bangles on my hands
And decorate my feet with jewelled anklets.
Her yellow-robed lover performed
According to whatever Radha said.

Plate 37, 11th Canto, Couplet 12

The fair cowherd-girls,
As bright as saffron
Are rushing to meet their lovers
The darkness is as dense as *tamal* leaves,
Presenting itself as a touchstone
To test the gold of their love.

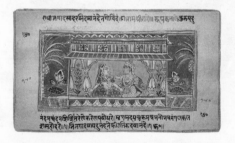

Plate 39, 12th Canto, Couplet 12

O Yadava hero, your hand is cooler
Than sandalwood balm on my breast
Paint a leaf design with deer musk here on my breast
She told the joyful Yadava hero, playing to her delight.

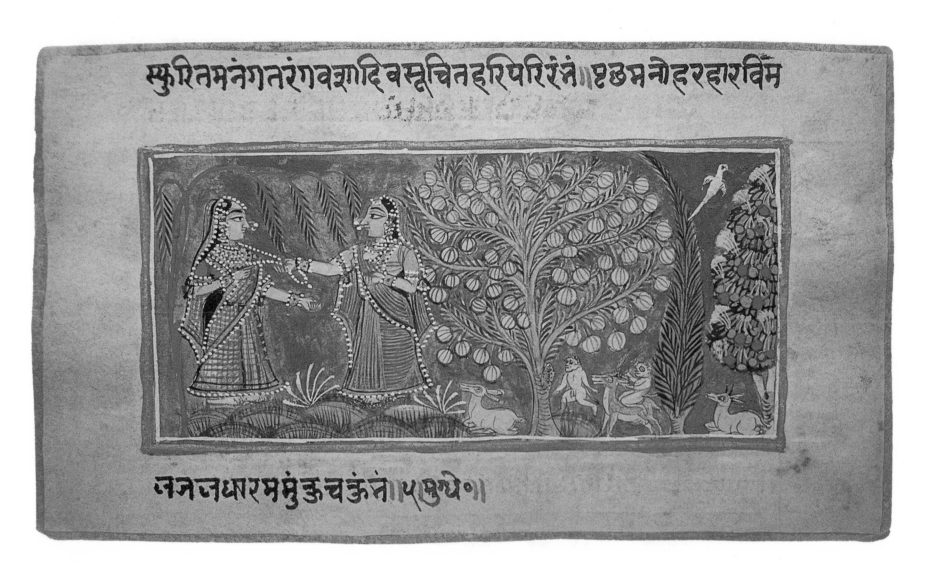

Plate 36 **Radha's friend inspires her**

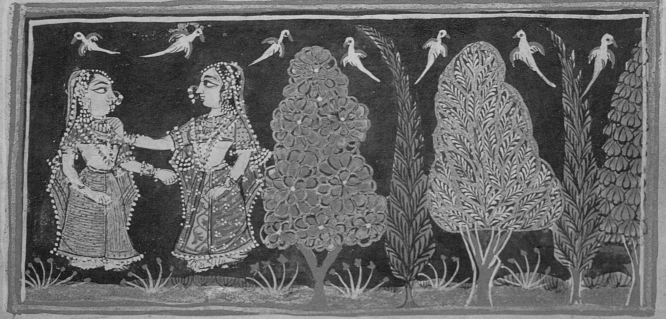

ज्ञमाजदखनीजनिनंतमिस्रंत्रिमहेमनिक्षीयलतांतनीति॥३॥

Plate 37 **Radha and her friend**

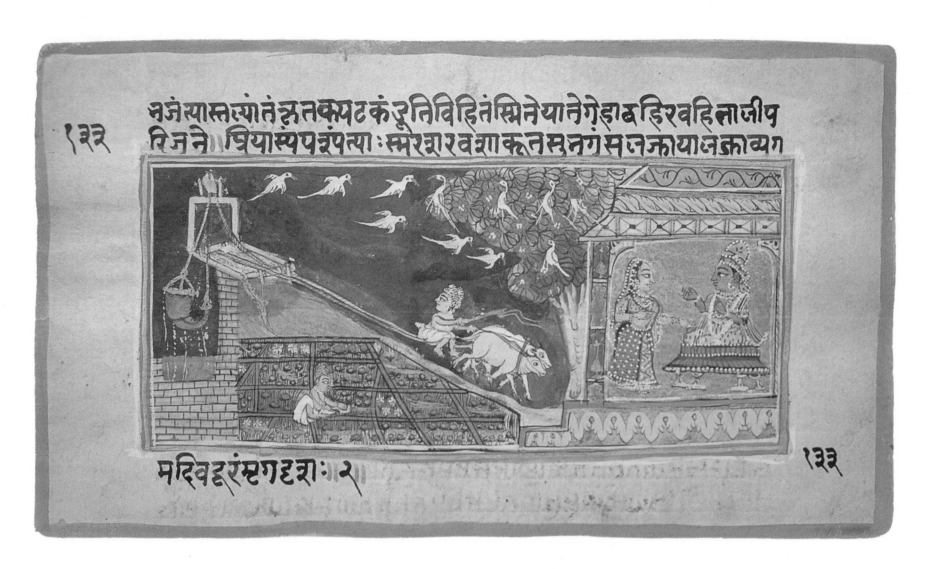

Plate 38 **Radha reaches Krishna**

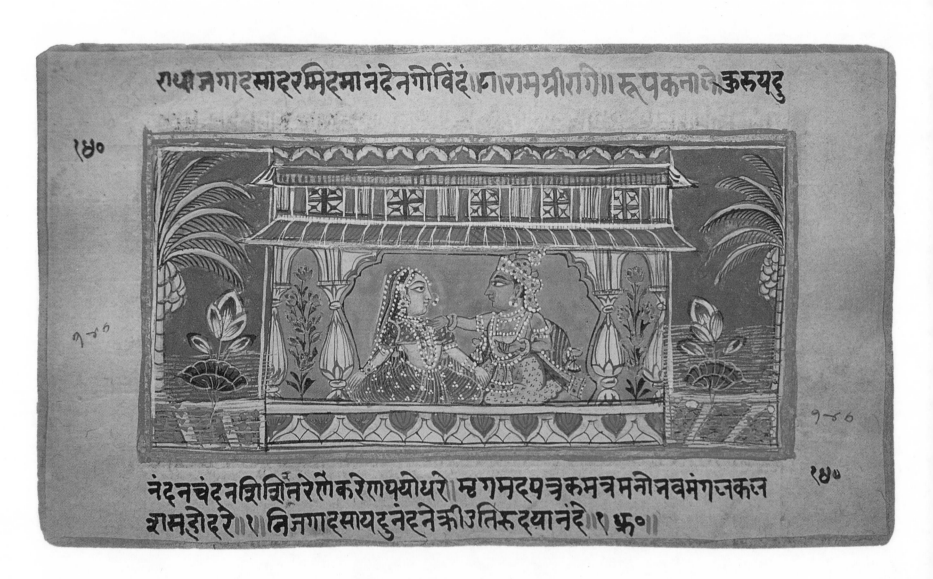

Plate 39 **Radha meeting Krishna**

रचयऊचयोःपत्रेचित्रंऊरुष्ककपोलयोर्घटयजघनेकांचिंमुचस्त्रजाकबरी

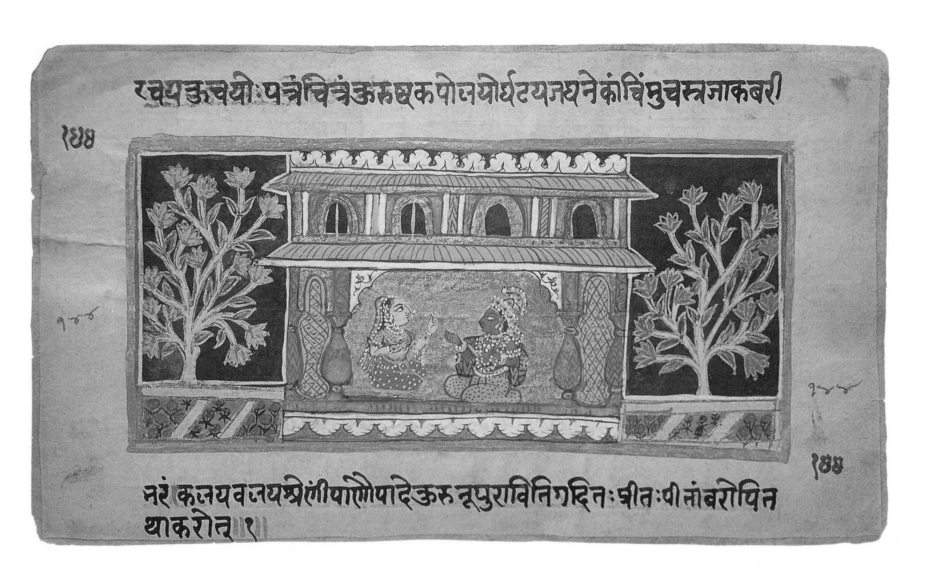

नरंकजयवजयश्रेंणीपाणौपादेऊरुनूपुराविनिगद्दिनःचीतःवींबरोचिन
थाकरोत् ९

Plate 40 **Radha requesting Krishna to decorate her**

गुर्जरीरागे घतीमंवताळे गुर्जरीरागिणी स्वरूपा श्यामासुकेशीमलयद्रुमा

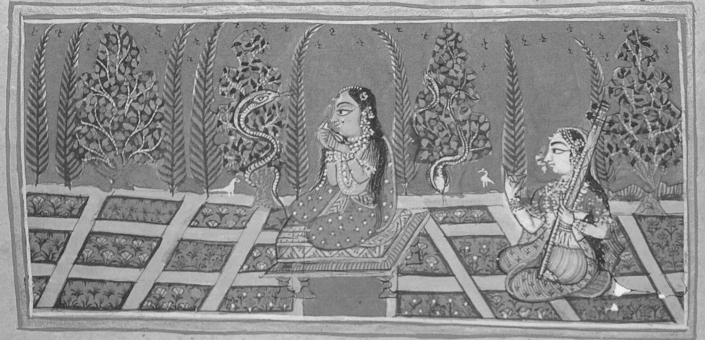

णंद्हृदृत्रसच्रवत्त्ययाता क्रतिःस्वराणांद्धतीविनागंनंत्रीमुखादक्षिण
गर्जरीय १

Plate 41 *Gurjari Ragini*

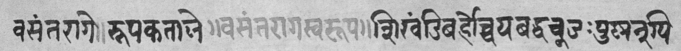

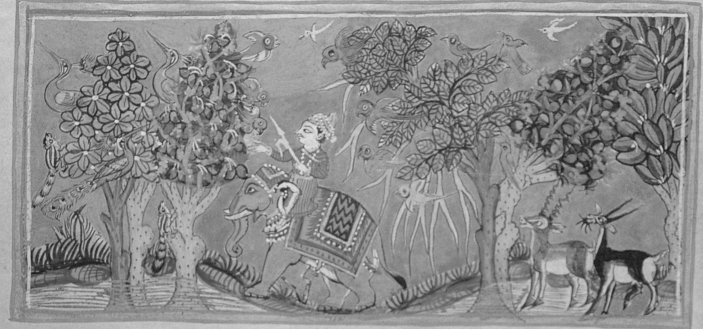

Plate 42 *Vasant Raga*

Plate 43 *Karnat Raga*

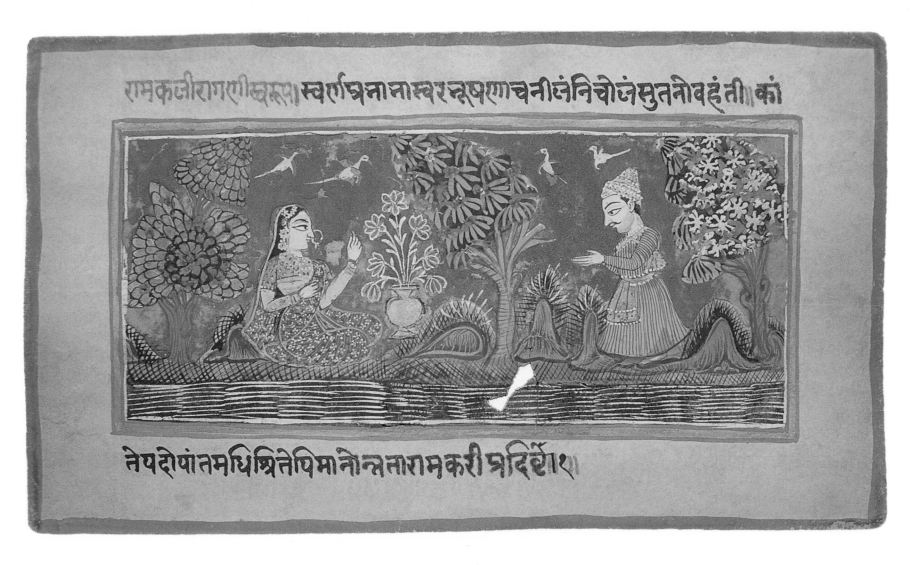

रामकलीरागिणीचरूपा स्वर्णप्रभा नास्वरदूषणाचनीलंनिचोळंसुतनोवहंती कां

नेपदीपांतमधिश्रितेणिमानौन्नतारामकरीप्रदिर्शेण

Plate 44 *Ramkali Ragini*

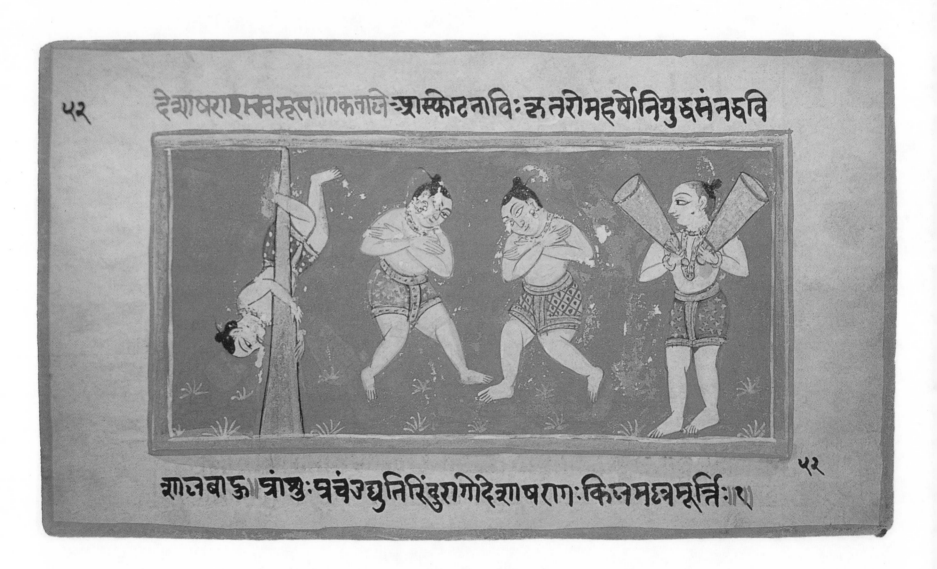

Plate 45 *Deshan Raga*

Bibliography

Agrawal, Vasudev S. *The Heritage of Indian Art*. Delhi: Publication Division of India, 1964.

Ambalal, Amit. *Krishna as Shrinathji*. Ahmedabad: Mapin Publishing Pvt. Ltd., 1995.

Archer, W.G. *Kalighat Paintings*. London: Her Majesty's Stationery Office, 1971.

———. *Love Songs of Vidyapati*. Delhi: Motilal Banarsidass, 1987.

Arts of Bengal. London: Whitechapel Art Gallery, 1979.

Bach, Hilde. *Indian Love Painting*. Lustre Press Pvt. Ltd., 1985.

Banerjee, P. *The Life of Krishna in Indian Art*. New Delhi: National Museum, 1978.

Bhattacharya, Bholanath. *Krishna in the Traditional Painting in Bengal*. Calcutta: B.K. Banerjee, 1972.

Brijbhushan, Jamila. *The World of Indian Miniatures*. Japan: Kodansha International Ltd., 1979.

Brunel, Francis. *Splendour of Indian Miniatures (Miniatures De L'inde)*. New York: Vilo, 1981.

Chhavi. Vol. I. Banaras: Bharat Kala Bhawan, 1971.

Chhavi. Vol. II. Banaras: Bharat Kala Bhawan, 1981.

Coomarswamy, A.K. *Arts and Crafts of India and Ceylon*. London: T.N Foulis: 1919.

———. *Dance of Shiva*. New York: Noonday Press, 1918.

Das, Asok Kumar. *Dawn of Mughal Painting*. Bombay: Vakils, Feffer and Simons Limited, 1982.

Dasa, Raikrishna. *Bharat ki Chitrakala*. Allahabad: Bharti Bhandar, Leader Press, 1974.

Dehejia, Vidya. *Devi: The Great Goddess*. Washington: Arthur M. Sackler Gallery, Mapin Publishing and Prestel Verlag, 1999.

Devre, Shivaji. *Ras Sahitya Ka Loktatvik Adhyayan*. Kanpur: Vidhya Prakashan, 1995.

Dinkar, Ramdhari Singh. *Sanskrati ke Char Adhyaya*. 8th edition. Ahmedabad: Lokbharti Prakashan, 1993.

Diwedi, Hajari Prasad. *Hindi Sahitya Ki Bhumika*. Rajkamal Prakashan, 1991.

———. *Sur Sahitya*. Bombay: Hindi Granth Ratnakar, 1956.

Ebeling, Klaus. *Ragmala Painting*. New Delhi: Ravi Kumar, 1973.

Facets of Indian Art. London: Victoria & Albert Museum, 1986.

Fine Oriental Miniatures, Manuscripts, Islamic Works of Art and 19th Century Paintings. New York: Sotheby Parke Bernet Inc., 1979.

Ganguly, O.C. and A. Goswami. *The Art of Chandellas*. Calcutta: 1957.

Gerolla, Vachaspati. *Bhartiya Chitrakala*. New Delhi: Chaukhamba Sanskrit Pratisthan, 1990.

Ghosh, D.P. *Medieval Indian Paintings: Eastern School*. Delhi: Sundeep Prakashan 1982.

Goswamy, B.N. *Essence of Indian Art*. Ahmedabad: Mapin Publishing, 1986.

——, ed. *Indian Painting: Essays in Honor of Karl J. Khandalavala*. New Delhi: Lalit Kala Akademi, 1995.

—— and Eberhard Fischer. *Pahari Masters: Court painters of Northern India*. Delhi: Oxford, 1997.

Gupta, R. D. *Eastern Indian Manuscript Painting*. Bombay: D.B. Taraporewala Sons and Co. Pvt. Ltd., 1972.

Gupta, Shashibhushandas. *Shriradha ka Kram Vikas*. Varanasi: Hindi Pracharak Pustakalaya, 1956.

Guy, John and Deborah Swallow, eds. *Arts of India 1550-1900*. London: Victoria and Albert Museum, 1990.

Havell, E.B. *A Handbook of Indian Art*. London: John Murray, 1927.

Hawley, John Stratton. *The Divine Consort Radha and the Goddesses of India*. Boston: Beacon Press, 1986.

Jain, Jyotindra. *Kalighat Painting*. Ahmedabad: Mapin Publishing, 1999.

Kar, Leela Shiveshwar. *Chaurpanchasika: A Sanskrit Love Lyric*. Reprint. New Delhi: National Museum, 1994.

Khandalava, Karl. *Painting of Bygone Years*. Bombay: Vakils, Feffer and Simons Limited, 1991.

Khare, M.D. and P. Khare. *Splendour of Malwa Paintings*. New Delhi: Cosmo Publications, 1983.

Kossak, Steven. *Indian Court Painting: 16th-19th Century*. London: Thames and Hudson, 1997.

Kramrisch, Stella. Painted Delight. Philadelphia: Philadelphia Museum of Art, 1986.

Krishna of the Bhagwat Purana, the Geet Govinda and Other Texts. New Delhi: National Museum, 1982.

Krishna: The Divine Lover Myth and Legend through Indian Art. New Delhi: B.I. Publications, 1982.

Kumari, Kaushal. *Geet Govinda Sahitiyaka Adhyayan*. New Delhi: Suman Prakashan, 1993.

Lodha, Kalyanmal. *Bhartiya Sahitya mein Radha*. New Delhi: National Publishing House, 1988.

Losty, J.P. *Indian Book Painting*. London: The British Library, 1986.

——. *Indian Paintings in the British Library*. New Delhi: Lalit Kala Akademi, 1986.

Majumdar, R.C., ed. *History and Culture of the Indian People*. Vol. V. Bombay: Bhartiya Vidya Bhawan, 1966.

Meetal, Dwarkaprasad. *Hindi Sahitya mein Radha*. Mathura: Jawahar Pustakalaya, 1970.

Miller, Barbara Stoler. *The Gita Govinda of Jaydeva: Love Songs of the Dark Lord*. Delhi: Motilal Banarsidass, 1977.

Mishra, Keshav Chandra. *Chandel Aur unka Rajatvakal*. Kashi: Nagri Pracharini Sabha, 1954.

Mishra, Vidhya Niwas. *Radha Madhava Rang Rangi: Geet Govinda ki Saras Vyakhya*. New Delhi: Bhartiya Gyanpeeth, 1998.

Music in Art. New Delhi: National Museum, 1993.

Neeraj, Jai Singh. *Splendour of Rajasthani Painting*. New Delhi: Abhinav Publications, 1991.

—— and Bhagwatilal Sharma. *Rajasthan ki Sanskratik Parampara*. Delhi: Ravi Kumar, 1999.

Pal, Pratapaditya. *Dancing to the Flute: Music and Dance in Indian Art*. Sydney: Thames and Hudson, 1997.

——. *Indian Painting*. Vol. I. Ahmedabad: Los Angeles County Museum of Art and Mapin Publishing, 1993.

——, ed. *Buddhist and New Studies*, XXXIX No. 4. Mumbai: Marg Publications, n.d.

Prakash, Vidya. *Khajuraho, a Study in the Cultural Conditions of Chandella Society*. Reprint. Bombay: D.B. Taraporevala Sons and Co. Pvt. Ltd., 1982.

Prasad, Kamala Prasad, ed. *Bhartendu Harishchandra*. New Delhi: National Book Trust, n.d.

Randhawa, M.S. *Indian Painting: The Scene, Themes and Legends*. Rev. ed. Bombay: Vakils, Feffer and Simmons Limited, 1980.

——. *Kangra Paintings of the Gita Govinda*. 2nd impression. New Delhi: National Museum, 1982.

Rawson, Philip. *Introducing Oriental Art*. London: Hamlyn, 1973.

Ray, N. *Idea and Image in Indian Art*. New Delhi: Munshiram Manoharlal, 1973.

Redington, James D., SJ. *Vallabhacharya on the Love Games of Krsna*. Delhi: Motilal Banarsidass, 1990.

Sharma, Ramcharanlal. *Hindi Sahitya mein Ashtachhapi aur Radhavallabhiya Kavya*. Mathura: Jawahar Pustakalaya, n.d.

Sharma, Sita. *Krishna Leela Theme in Rajasthani Miniatures*. Meerut: Pragati Prakashan, 1987.

Shastri, Ramchandra Verma. *Jaidev Krat Geet Govinda*. Delhi: Gyanganga, 1997.

Sivaramamurti, C. *The Art of India*. New York: Harry N. Abrams, 1974.

Stierlin, Henri. *Hindu India from Khajuraho to the Temple City of Madurai*. London: Taschen, 1998.

Thomas, P. *Kam Karpa or the Hindu Ritual of Love*. Bombay: D.B. Taraporevala Sons and Co. Pvt. Ltd., 1960.

Tiwari, J.N. *Goddess Cult in Ancient India*. New Delhi: Sundeep Prakashan, 1985.

Topsfield, Andrew and Milo Cleveland Beach. *Indian Paintings and Drawings from the Collection of Howard Hodgkin*. London: Thames and Hudson, 1992.

Tripathi, R.P. *Rise and Fall of the Mughal Empire*. Allahabad: Indian University Press, 1963.

Upadhayaya, Baldev. *Bhartiya Vangmaya mein Shriradha*. Patna: Hindi Rashtra Bhasha Parishad, 1963.

Upadhyaya, Narmada Prasad. *Prabhas kee Seepiyan*. New Delhi: Praveen Prakashan, 1999.

Vatsyayan, Kapila. *Geet Govinda*. Allahabad: Lokbharti Prakashan, 1988.

——. *Jaur Gita Govinda*. New Delhi: National Museum, 1979.

——. *Mewari Gita Govinda*. New Delhi: National Museum, 1987.

——. *The Bundi Geet Govinda*. Varanasi: Bharat Kala Bhawan, 1981.

Verma, Pawan K. *Krishna: The Playful Divine*. Delhi: Viking Publishers, 1993.

Welch, Stuart Cary. *India: Art and Culture*. Ahmedabad: Mapin Publishing, 1985.

Zebrowski, Mark. *Deccani Painting*. New Delhi: Roli Books International, 1983.

Glossary

alhadini shakti: literally, the supreme power of Krishna; an epithet for Radha

amla: Indian gooseberry; *Emblica officinalis*

Apbhransha: an ancient Indian language

ashoka: Ashoka tree; *Saraca indica*

ashtapadi: songs of eight stanzas

asthachhap: nomenclature for eight poets who wrote verses in appreciation of Krishna, in medieval times in the Brij dialect (regional language of Brij—the region comprising Agra, Mathura, Gokul and Vrindavana). The eight poets of *asthachhap* were Kumbhan Das, Surdas, Parmanand Das, Krishna Das, Govind Swami, Chheet Swami, Chaturbhuj Das and Nand Das.

bangri: bangle

bani thani: Rajasthani word for heroine, used particularly for a well-dressed and well-ornamented *nayika* or heroine

Banke Bihari: Radha and Krishna as a couple when presented as an idol

Bhaktamal: literally, a garland of devotees; a composition of the medieval saint Nabhadas

bhakti: devotion; the tradition of Bhakti which flourished in India has its roots in the Vedic era. It reached its zenith in medieval times when poets like Tulsidas and Surdas wrote the *Ramayana* and *Sursagar*. Several cults developed in India in this period and the activities of the devotees led to the Bhakti movement.

bhramar geet: a song sung by *gopis*

bujatti: an ornament for the neck

chameli: jasmine; *Jasminum tortuosum*

champa or *champak*: *Michelia champaca*

chinz petty: neck ornament for women

choti: hair tied up in a ponytail

chuda: bangle

chudi: thin bangle

chunni: veil

Dasbodha: a book written by Samartha Ramdasa, a great saint and guru of the great warrior Shivaji

dhoti: loose cloth worn by men on the lower body

dhruwaka: a musical term, a 'refrain' repeated after each couplet

dupatta: scarf

duti: messenger

Dwapara Yug: the era in which Krishna was born

Gamaka: Manipuri style of dance where the expressions are not realistic but indicative

ganavrata: a musical term: moric meters when further patterned into measures.

gandharva kala kaushal: the skill of *gandharva* art; the *gandharvas* are known in Indian tradition for their superb artistic expertise

ghunghri: a type of clothing worn by men, used for protection from rains; it is a garment for the upper body and covers the head

gopi: milkmaid; female companion of Krishna

gudhal: China rose; *Rosa Chinensis*

Gurugrantha Sahib: the sacred book of Sikhs

Hallisak: a folk dance like *rasa* mainly performed in Khandesh

Jaideva Smarak Mela: an annual fair held in the memory of Jaideva in Kenduli or Kindubilva, the birth place of Jaideva

jhumka: a kind of earring

juda: a lock of hair

juhi: jasmine; *Jasmium auriculatum*

Kanha Desh: term used for Khandesh

karanja: Molucca bean; *Caesalpinia bonducella*

karnaphool: a kind of earring

kela: banana; *Musa sapientum*

keora: rampe; *Sonneralia aoelala*; a type of cactus that gives off a fragrance

Khadi Boli: the present form of Hindi language

khandita nayika: the gloomy aspect of a heroine

khor: symbol of a married woman whose husband is alive

kunja: a grove or thicket

Lali of Barsana: Radha, the daughter of Barsana

leela: divine play

lehenga: skirt

Mahabharata: great war; Indian epic composed by the great sage Vyasa

malvat: symbol of married women, synonym of *khor*

manabhava: sentiment of anger

mandap: pavilion

mandara or *madara*: ak; *Calotropis gigantia*

mangal sutra: necklace worn by married women

manini: angry

mantra: hymn

marg sangeet: music of the elite

mathapatti: an ornament of the forehead

matki: an earthen pot used for keeping water or preserving milk and curd

matravrata: a musical term; moric meters when defined by the number of beats

morpankhi mukut: crown with a peacock's feather

mridanga: percussion instrument

murakka: Persian word for album

nariyal: coconut; *Cocos nucifera*

nath: ornament for the nose

navvari sari: sari of nine yards of cloth

nayaka: hero

nayika: heroine

orhni: a stole worn by women

pada: stanza

parambi: Betel palm; *Areca catechu*

parijat: Spanish cherry; *Mimusops elengi*

payal: anklet

pothi: handbound manuscript

Prakrata: an ancient Indian language

purana: Hindu's religious texts

raga: melodic pattern

Ramayana: the oldest Indian epic

rasa: circular dance performed by Krishna along with milkmaids in the forests of Vrindavan is known as *rasa*

Rathyatra: procession which takes place in Jagannath Puri

Rigveda: the oldest Indian text

sadafuli: periwinkle; *Vinca rosea*

samadhi: memorial

shakti tatva: element of power related to goddess Kali or Durga

shela: Marathi word for a type of long scarf

shloka: verse

shringara: make-up

surahi: an earthen pot

take: musical term; refrain

Tantra: scripture dealing especially with the technique and ritual of meditative and sexual practices

tantrik sadhu: a devotee who performs the rituals through meditative and sexual practices

teeka: a mark on the forehead symbolic of a worshipper, Hinduism has several sects and followers of a particular sect can be easily identified by this mark drawn on the forehead with sandalwood paste

thali: plate

tipai: a technique adopted for the miniature painting

tulsi: Holy basil; *Ocimum samctum*

Upanishad: Hindu religious text

uparna: Marathi word for a type of long scarf

Uttam Purush: a great man

vasaksajja: a *nayika* who is well-dressed and bejeweled, waiting for the *nayak*

Vasant Panchami: festival of spring

Vithoba: Krishna

Vitthal: Krishna